DAVID BUSCH'S COMPACT

# NIKON® V1/J1

## David D. Busch

**Course Technology PTR**
*A part of Cengage Learning*

COURSE TECHNOLOGY
CENGAGE Learning·

Australia, Brazil, Japan, Korea, Mexico, Singapore, Spain, United Kingdom, United States

# COURSE TECHNOLOGY
## CENGAGE Learning®

**David Busch's Compact Field Guide for the Nikon® V1/J1**
**David D. Busch**

**Publisher and General Manager, Course Technology PTR:**
Stacy L. Hiquet

**Associate Director of Marketing:**
Sarah Panella

**Manager of Editorial Services:**
Heather Talbot

**Senior Marketing Manager:**
Mark Hughes

**Executive Editor:**
Kevin Harreld

**Project Editor:**
Jenny Davidson

**Series Technical Editor:**
Michael D. Sullivan

**Interior Layout Tech:**
Bill Hartman

**Cover Designer:**
Mike Tanamachi

**Indexer:**
Katherine Stimson

**Proofreader:**
Sara Gullion

For product information and technology assistance, contact us at **Cengage Learning Customer & Sales Support, 1-800-354-9706.**

For permission to use material from this text or product, submit all requests online at **cengage.com/permissions**. Further permissions questions can be e-mailed to **permissionrequest@cengage.com**.

Nikon is a registered trademark of Nikon Corporation in the United States and other countries.

All other trademarks are the property of their respective owners.

All images © David D. Busch unless otherwise noted.

Library of Congress Control Number: 2012932050

ISBN-13: 978-1-133-93839-2

ISBN-10: 1-133-93839-6

Cengage Learning is a leading provider of customized learning solutions with office locations around the globe, including Singapore, the United Kingdom, Australia, Mexico, Brazil, and Japan. Locate your local office at: **international.cengage.com/region**.

Cengage Learning products are represented in Canada by Nelson Education, Ltd.

For your lifelong learning solutions, visit **courseptr.com**.

Visit our corporate Web site at **cengage.com**.

Printed in the United States of America
1 2 3 4 5 6 7 14 13 12

# Contents

# Introduction

Throw away your cheat-sheets and command cards! Are you tired of squinting at tiny color-coded tables on fold-out camera cards? Do you wish you had the most essential information extracted from my comprehensive *David Busch's Nikon V1 Guide to Digital Movie Making and Still Photography* and *David Busch's Nikon J1 Guide to Digital Movie Making and Still Photography* in a size you could tuck away in your camera bag? I've condensed the basic reference material you need in this handy, lay-flat book, *David Busch's Compact Field Guide for the Nikon V1/J1*. In it, you'll find the explanations of *why* to use each setting and option—information that is missing from the cheat-sheets and the book packaged with your camera. You *won't* find the generic information that pads out the other compact guides. I think you'll want to have both this reference and my full-sized guide—one to help you set up and use your Nikon V1 or J1, and the other to savor as you master the full range of things these great cameras can do.

# About the Author

With more than a million books in print, **David D. Busch** is the world's #1 selling digital camera guide author, and the originator of popular digital photography series like *David Busch's Pro Secrets, David Busch's Quick Snap Guides,* and *David Busch's Guides to Digital SLR Photography*. As a roving photojournalist for more than 20 years, he illustrated his books, magazine articles, and newspaper reports with award-winning images. Busch operated his own commercial studio, suffocated in formal dress while shooting weddings-for-hire, and shot sports for a daily newspaper and upstate New York college. His photos and articles have appeared in *Popular Photography & Imaging, Rangefinder, The Professional Photographer*, and hundreds of other publications. He's also reviewed dozens of digital cameras for CNet and *Computer Shopper*, and his advice has been featured on NPR's *All Tech Considered*. Visit his website at www.dslrguides.com/blog.

# Chapter 1

# Quick Setup Guide

This chapter contains the essential information you need to get your Nikon V1/J1 prepped and ready to go. You'll learn how to use a few of the basic controls and features, and how to transfer your photos to your computer. If you want a more complete map of the functions of your camera, skip ahead to Chapter 2.

## Pre-Flight Checklist

The initial setup of your Nikon V1 or J1 is fast and easy. You just need to learn a few controls, charge the battery, attach a lens, and insert a Secure Digital card.

### Charging the Battery

When the battery is inserted into the MH-25 (for the V1) or MH-27 (for the J1) charger properly (it's impossible to insert it incorrectly), an orange Charge light begins flashing, and remains flashing until the status lamp glows steadily, indicating that charging is finished, generally within two to three hours. When the battery is charged, slide the latch on the bottom of the camera and ease the battery in, as shown in Figure 1.1.

### Introducing Menus and the Multi Selector

You'll find descriptions of most of the controls used with the Nikon V1/J1 in Chapter 2, which provides a complete "roadmap" of the cameras' buttons and dials and switches. However, you may need to perform a few tasks during this initial setup process, and most of them will require the MENU button and the multi selector pad.

- **MENU button.** It's located to the lower right of the LCD. When you want to access a menu, press it. To exit most menus, press it again.

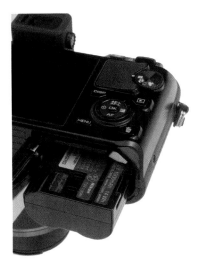

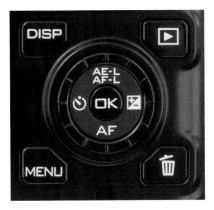

**Figure 1.1** Insert the battery in the camera; it only fits one way.

**Figure 1.2** The MENU button (lower left) and multi selector pad (center).

■ **Multi selector pad.** A thumbpad-sized button with labels representing secondary functions at the North, South, East, and West "navigational" positions, plus a button in the center marked "OK" (see Figure 1.2). The labels differ slightly between cameras: the V1 has an AF (autofocus) label at the South position, while the J1 is marked with a lightning bolt electronic flash icon. With either the V1 or J1, the multi selector is used to activate one of the labeled functions, and for navigation; for example, to navigate among menus on the LCD or to choose one of the 11 focus points, or to advance or reverse display of a series of images during picture review. The OK center button is used to confirm your choices and select a highlighted item from a menu.

## Setting the Clock

The in-camera clock might have been set for you by someone checking out your camera prior to delivery. If you do want to set it, press the MENU button, use the multi selector (that thumb-friendly button I just described, located to the immediate lower right of the back-panel LCD) to scroll down to the Setup menu (represented by a yellow wrench icon), press the multi selector button to the right, and scroll down to the Time Zone and Date choice, and press right again. The options will appear on the screen that appears next. Keep in mind that you'll need to reset your camera's internal clock from time to time, as it is not 100-percent accurate.

## Mounting the Lens

If your V1 or J1 has no lens attached, you'll need to mount one before shooting:

1. Select the lens and loosen (but do not remove) the rear lens cap.

2. Remove the body cap on the camera by rotating the cap towards the shutter release button.

3. Once the body cap has been removed, remove the rear lens cap from the lens, set it aside, and then mount the lens on the camera by matching the alignment indicator on the lens barrel with the white marking on the camera's lens mount (see Figure 1.3). Rotate the lens toward the shutter release until it seats securely.

4. When you turn the camera on, you may be prompted to unlock and extend the lens (at this writing, the 10-30mm and 30-110mm zooms require this step). You can also extend the lens prior to powering up the camera; doing so automatically turns the camera on.

5. If the lens is furnished with a lens hood that is bayoneted on the lens in the reversed position, twist it off and remount with the "petals" (if present) facing outward. A lens hood protects the front of the lens from accidental bumps, and reduces flare caused by extraneous light arriving at the front of the lens from outside the picture area.

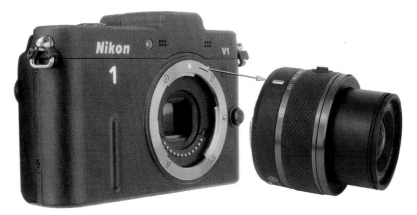

**Figure 1.3** Match the indicator on the lens with the white dot on the camera mount to properly align the lens with the bayonet mount.

## Adjusting Diopter Correction

This step is for the V1 only. If you are a glasses wearer and want to use the V1 without your glasses, or to add further correction, you can take advantage of the camera's built-in diopter adjustment, which can be varied from –3 to +1.0 correction. Press the shutter release halfway to illuminate the indicators in the electronic viewfinder, then rotate the diopter adjustment knob next to the viewfinder (see Figure 1.4) while looking through the viewfinder until the indicators appear sharp.

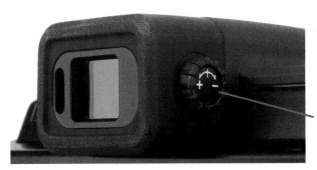

**Figure 1.4**
Viewfinder diopter correction from –3 to +1 can be dialed in.

*Diopter adjustment knob*

## Inserting and Formatting a Secure Digital Card

You've probably set up your camera so you can't take photos without a memory card inserted. (There is a Slot Empty Release Lock in the Setup menu that enables/disables shutter release functions when a memory card is absent—learn about that in Chapter 3.) So, your final step will be to insert a memory card. Slide the lever on the door on the bottom of the body (where the battery is inserted) towards the tripod socket to release the cover, and then open it. (You should only remove a memory card when the camera is switched off, or, at the very least, the yellow-green memory access light at the bottom right of the back panel that indicates the camera is writing to the card is not illuminated.)

Insert the memory card with the label facing the back of the camera oriented so the edge with the contacts (the metallic "fingers" of a Secure Digital card) goes into the slot first. Close the door, and, if necessary, format the card. A Secure Digital card can be removed just by pressing it inward; it will pop out far enough that you can extract it. (See Figure 1.5.)

**Figure 1.5**
The Secure
Digital card is
inserted with the
label facing the
back of the
camera.

I recommend formatting the memory card before each shooting session, to ensure that the card has a fresh file system, and doesn't have stray files left over. Format *only* when you've transferred all the images to your computer, of course.

■ **Setup menu format.** To use one of the recommended methods to format a memory card, press the MENU button, use the up/down buttons of the multi selector (that thumb-pad-sized control to the right of the LCD) to choose the Setup menu (which is represented by a wrench icon), navigate to the Format Memory Card entry with the right button of the multi selector, and select Yes from the screen that appears. Press OK to begin the format process.

# Selecting a Shooting Mode

Your Nikon 1 cameras have four distinctly different shooting modes: Motion Snapshot, Smart Photo Selector, Still Image mode, and Movie mode. (See Figure 1.6.)

■ **Motion Snapshot.** This mode lets you record movie clippettes of about a second in length, played back in slow motion over about 2.5 seconds, along with a still photograph. This is a great feature for grabbing special moments. You can choose a background music "theme" from Beauty, Waves, Relaxation, and Tenderness motifs.

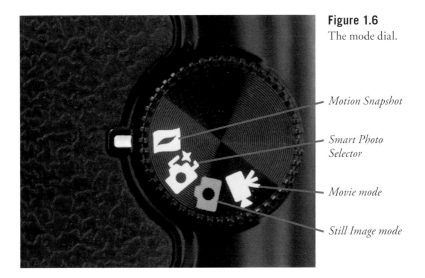

**Figure 1.6**
The mode dial.

*Motion Snapshot*

*Smart Photo Selector*

*Movie mode*

*Still Image mode*

- **Smart Photo Selector.** The V1/J1 takes up to 20 pictures, examines them, and uses its built-in smarts to choose the best composed and sharpest image, plus four additional candidates. Just press the shutter release down halfway to begin storing images temporarily in your camera's memory. The camera will refocus as necessary to follow a moving subject. Press the shutter button down all the way to end capture (the camera will stop grabbing pictures all by itself after about 90 seconds). Ten pictures taken just before and just after you stop capture are retained. You will then be given the opportunity to choose your favorite from these, and the others can be deleted.

- **Still Image mode.** This is the general-purpose photography mode you'll use most of the time. The rest of this chapter (after the introduction to movies that follows this section) will be devoted to using Still Image mode to take your first pictures.

- **Movie mode.** Use this mode to take either high-definition (HD) movies or slow-motion movies (at up to 400 frames per second, played back at about 7.5 percent of normal speed).

# Using Motion Snapshot Mode

The Nikon V1 and J1's Motion Snapshot mode provides short, slow-motion glimpses of moments you capture in easy to digest bites. When you spin the mode dial to the Motion Snapshot position, the camera is poised to capture a one-second clip whenever you specify. Here's a brief rundown of how it works:

1. **Start "buffering."** When you're almost ready to capture a motion snapshot, press the shutter release button down halfway. The camera will begin capturing motion in your scene and temporarily store it in the camera's memory, or *buffer*, waiting until you decide to actually save a moment in time. This buffering continues for about 90 seconds, or until you decide to take the motion snapshot.

2. **Capture the sequence.** When you choose to record a sequence, press the shutter release the rest of the way down. At that instant, about one second of the video currently in the buffer is saved, embracing the moments *just before* you press the button to *just after*.

3. **Save to the memory card.** The motion snapshot, along with a still photo of the moment, is then saved to your memory card permanently for you to enjoy later.

4. **Review the snapshot.** The V1/J1 next displays the motion snapshot you just shot in 2.5X slow motion, accompanied by theme music, and finishing with the still photograph of your scene.

## Shooting Motion Snapshots

Follow these steps to record your own motion snapshots.

1. **Shift to Motion Snapshot mode.** Rotate the mode dial to the Motion Snapshot position, shown in Figure 1.6.

2. **Select a theme.** Press the F button to the left of the zoom bar. Use the directional buttons to choose from Beauty, Waves, Relaxation, or Tenderness theme music.

3. **Frame the photo and begin buffering.** You can use either the LCD or the EVF to compose your image. Press the shutter release halfway to begin capturing the scene to the camera's memory buffer.

4. **Capture.** Gently press the shutter release down the rest of the way to capture the sequence. Note that audio is not recorded; a motion snapshot captures only a video representation of the scene.

5. **Review.** The still snapshot will be displayed for a few seconds to allow you to confirm that you've captured the motion snapshot.

---

**SHOOTING MOTION SNAPSHOTS WITH FLASH**

If you own the V1 model and have the optional SB-N5 flash unit, you've got an illuminator that will brighten your scene for a few seconds while shooting motion snapshots. It's a perfect supplementary light source when you want to brighten indoor pictures or fill in shadows outdoors. Slide the accessory shoe cover off and mount the SB-N5 flash, and rotate the switch on the back to the On position. Press the shutter release halfway to begin capturing the scene to the V1's memory buffer. The white LED on the front of the SB-N5 will illuminate. Buffering will continue for a maximum of about six seconds (because the LED does drain the battery), or until you press the shutter release down all the way, taking the picture. If buffering stops, lift your finger from the shutter release and press halfway again to resume.

---

## Viewing and Reviewing Your Motion Snapshots

Once you've recorded one or more motion snapshots, you can view them as a slide show.

1. **Press Playback.** The most recently shot image will appear on the screen.

2. **Select motion snapshot to view.** Use the left/right directional buttons to navigate to the sequence you want to view. Press OK to view.

3. **Watch your motion snapshot.** The snapshot and its audio theme will be played back over a period of about 2.5 seconds, and then the on-screen image will fade to the still photo version, and the theme music will continue for about 10 seconds total.

4. **Adjust playback volume.** While the clip is playing, you can adjust the volume by pressing the zoom bar located to the upper right of the back of the camera up or down.

5. **Delete (optional).** You can trash the motion snapshot by pressing the Delete button twice. Or, you can cancel and exit by pressing the Playback button or tapping the shutter release.

# Using Smart Photo Selector Mode

In this mode, the camera captures 20 exposures in its buffer at a rate of 30 frames per second. It then examines the pictures, rejecting those with the most blur, with subjects eyes closed, and so forth, and presents you with the best shot and four additional candidates, which are all stored to the memory card.

Just follow these steps:

1. **Shift to Smart Photo Selector mode.** Rotate the mode dial to the Smart Photo Selector position.

2. **Mount the flash (optional).** If you own the V1 model and have the SB-N5 flash, it can provide extra illumination, as described under the Motion Snapshot description.

3. **Choose settings.** When in Smart Photo Selector mode, you can select from an array of adjustments, including Image Quality, Image Size, Color Space, Noise Reduction, Vibration Reduction, and Built-in AF assist. Note that you can't choose an exposure or metering mode, nor focus modes (except that the camera will automatically switch to close-up focusing if it detects that your main subject is located in the macro range).

4. **Frame the photo.** You can use either the LCD or the EVF (with the V1) to compose your image, with your main subject in the center of the frame.

5. **Begin buffering.** Press the shutter release halfway to begin capturing the scene to the memory buffer. The camera will adjust focus to accommodate subject movement closer or farther from the camera. AF-area brackets that appear in the frame as soon as you switch to Smart Photo show the area of focus. Buffering will continue for a maximum of about 90 seconds, or until you press the shutter button down to take the picture.

6. **Capture.** Gently press the shutter release down the rest of the way to capture the sequence of pictures.

7. **Review.** The image the camera decides is best is displayed on the monitor. If you're using the V1, the image will be displayed on either the EVF or LCD, depending on which you were using when the capture was made.

## Viewing and Reviewing Your Smart Snapshots

Viewing your Smart Photo Selector mode images is a bit counterintuitive, because the V1/J1 stores them all to your memory card, but won't "allow" you to look at them all, except when you use the procedure I'll describe next. The process is simple and easy to understand once you've tried it. Just follow these steps:

1. **Press Playback.** The most recently shot image will appear on the screen. The camera displays the series with a border resembling a stack of prints with the selected best shot on top of the stack.

2. **Scroll through Smart Photos.** Use the left/right directional buttons to navigate to the "best shot" of the series you want to view. The camera will let you view *only* the best shot of the series in normal playback mode. The others are on your card, but are skipped over during normal playback, and you need to jump through a small hoop to see them.

3. **Choose the series to view.** When you see the "best" shot of the series you want to review, make sure the Simple Details screen is shown (press the DISP button if necessary to view it), and press the OK button. In Simple Details playback mode, you'll be prompted to press the OK button to view the snapshot and its runners-up.

4. **Examine the images.** Use the left/right directional buttons to scroll through the four candidates. (See Figure 1.7.) If you see one you prefer to the "best" shot selected by the camera, press the OK button to upgrade its status.

5. **Delete (optional).** During best shot review, you can trash an individual image by pressing the Delete button. A screen appears with the options: This Image (to remove the current image) and All Except Best Shot (to delete the runner-up candidates). Press OK to confirm, and then select Yes from the next screen that appears to go ahead with trashing the selected image(s). Or, you can cancel and exit by pressing the Playback button.

6. **Return to normal playback.** Press the Playback button to exit best shot review.

**Figure 1.7**
Review the best shot and runners-up.

# Using Still Image Mode

Still Image mode is your all-purpose shooting mode used for most picture taking. It features Automatic Scene Selection (in which the V1 or J1 chooses from among Portrait, Landscape, Night Portrait, Close-Up, and Auto Scene modes), and the usual selection of semi-automatic and manual modes (Program, Shutter-priority, Aperture-priority, and Manual; commonly referred to as PSAM modes).

To use Still Image mode in its most basic form, just follow these steps:

1. **Shift to Still Image mode.** Rotate the mode dial to the Still Image mode position.

2. **Mount the flash (optional).** If you own the V1 and have the SB-N5 flash, you can use it, as described earlier under the Motion Snapshot description. I'll cover electronic flash in more detail in Chapter 5.

3. **Select exposure mode.** Press the MENU button, choose the Shooting menu, and scroll to Exposure Mode, press OK, and select Scene Auto Selector, Programmed auto, Shutter-priority auto, Aperture-priority auto, or Manual.

4. **Frame the photo.** Use the LCD on the J1; with the V1 you can use either the LCD or the EVF.

5. **Focus.** Press the shutter release halfway to focus the image. If the camera is successful at locking in focus, the focus area will be highlighted in green; otherwise, the focus area will glow red.

6. **Shoot.** Gently press the shutter release down the rest of the way to capture the picture. The image you've just taken will be shown on the display for a few seconds.

## Choosing a Shutter Type

With the V1, you can select either the mechanical or electronic shutter (the J1 has only an electronic shutter). The shutter is the component that exposes the sensor to light when the picture is taken. The Nikon V1 has a physical shutter at the focal plane that covers the sensor, and then opens during the exposure to capture the image. It also has an *electronic* shutter, like in the J1, that performs the same function. In use, the camera darkens the shutter by dumping the current image from the sensor chip electronically, then activating the sensor to capture light *only* for the duration of the exposure. This process is very fast, and can operate much more quickly than the mechanical shutter, providing speeds as brief as 1/16,000th second.

### Using the Mechanical Shutter

With the V1, you'll want to use the mechanical shutter for everyday use. Here are the most important considerations to take into account when choosing which to use:

■ **Shutter speed range.** The mechanical shutter offers shutter speeds from 30 seconds to 1/4,000th second. Although the electronic shutter offers higher speeds, this range is sufficient for virtually every scene you might want to photograph.

■ **Frame rates.** Because of its higher speeds, the electronic shutter can capture images at faster frame rates, which is why it is always used for shooting movies (at up to 60 frames per second) and for slow-motion video (at up to 1200 frames per second).

■ **Flash synchronization.** The mechanical shutter allows using electronic flash, such as the SB-N5 at shutter speeds up to 1/250th second; the electronic shutter can sync at speeds of only 1/60th second or slower. As you'll learn in Chapter 5, faster shutter speeds reduce the chance of "ghost" images caused by a secondary exposure from the ambient light (which becomes more likely the slower the shutter speed is).

■ **Less subject distortion.** When your subject is moving during the time the sensor is capturing the picture, the final image can suffer from several kinds of distortion. Parts of the image are exposed at different times, while the camera or subject move during exposure, producing a wobbly look ("jello" effect especially noticeable during video shooting), skew, or smear. The mechanical shutter minimizes these effects because the curtains that expose the sensor travel so quickly across the frame.

■ **Better image quality.** Mechanical shutters reduce an effect called "blooming" that can appear around bright highlights when using an electronic shutter. Images taken with an electronic shutter also tend to have higher levels of noise, a grainy texture that appears during the processing of the image.

■ **Audible noise.** Mechanical shutters do produce a clicking sound—there's no way around it—and electronic shutters can operate silently. So, if you must have absolutely silent operation, the electronic shutter is preferable.

To set the Nikon V1 to use the mechanical shutter, just follow these steps (you can also select one of these options using the Shutter Type entry in the Shooting menu):

1. **Choose Still Image mode.** Rotate the mode dial to the Still Image mode position.
2. **Press the F button.** Then use the multi selector directional buttons to select Mechanical Shutter, Electronic Shutter, or Electronic (Hi) Shutter.
3. **Confirm.** Press OK to confirm your choice.

## Using the Electronic Shutter and Electronic (Hi) Shutter

When you select either electronic shutter option, the following features are available:

■ **High Shutter Speeds.** In either electronic shutter mode, you can select shutter speeds faster than 1/4,000th second, specifically 1/5,000th, 1/6,400th, 1/8,000th, 1/10,000th, 1/13,000th, and 1/16,000th second when using Manual or Shutter-priority modes. The camera may select these faster shutter speeds, if required, in Program and Aperture-priority modes. In practice, however, speeds of 1/4,000th second or slower are all that you really need.

■ **Faster frame rates.** Continuous shooting is possible at about 5 frames per second when using the electronic shutter (the same as with the mechanical shutter). Switch to Electronic (Hi) Shutter, and the V1 defaults to 10fps. You can also choose 30fps or 60fps. The Electronic (Hi) Shutter is also used for slow-motion movies at reduced resolutions, at 400fps (640 × 240 pixels) or 1200fps (320 × 120 pixels).

■ **Silent shooting.** When using either electronic shutter mode, the V1 can shoot completely silently. This is a great option when capturing images in museums, at religious ceremonies, and at plays and other performances where shutter clicking might be obtrusive.

## Shooting Movies in Still Image Mode

When the Nikon V1 (but not the J1) is set to Still Image mode, you can record non-high-definition movies, using an aspect ratio of 3:2 (the same proportions as the still image frame), with a resolution of 1072 × 720 pixels. To shoot movies without exiting Still Image mode, just follow these steps:

1. **Start movie recording.** While shooting still photos, press the red movie record button. The V1 will immediately switch to Movie mode and the recording indicator will appear at the upper left of the screen. Audio will be recorded along with the video.

2. **Stop movie recording.** To stop shooting video, press the movie record button a second time. You can also switch back to still photography by pressing the shutter release button down all the way. The video recording will stop and a still photograph will be taken.

# Movie Mode

Movie mode is easy: just rotate the mode dial to the movie position, and press the red movie button down to start recording, and a second time to stop. Of course, you have quite a few other options when using Movie mode, and I'm including an entire chapter on shooting movies, in Chapter 6.

# Choosing a Still Image Release Mode

The release mode determines when (and how often) the Nikon 1 camera makes an exposure. Your V1 or J1 have several release modes when using Still Image shooting:

- **Single frame.** In single frame mode, the camera takes one picture each time you press the shutter release button down all the way. You can take as many photographs in this mode as you have room for on your memory card. To choose single frame mode, just follow these steps:

  1. Press the MENU button, located at the lower-right edge of the camera.
  2. When the menu screen pops up (see Figure 1.8, left), use the multi selector down button to scroll to Continuous, then press the multi selector right button to select the entry.
  3. When the Continuous screen appears (see Figure 1.8, right), use the up/down buttons to select Single Frame, and then press the OK button to confirm.

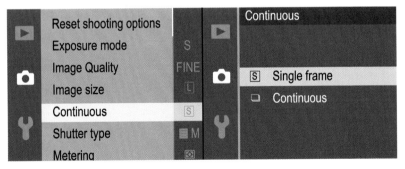

**Figure 1.8** In the Shooting menu, choose Continuous to set Single Frame or Continuous shooting modes (left), then select Single Frame or Continuous.

■ **Continuous.** This shooting mode can be set to produce bursts of up to 5 frames per second while the shutter release button is held down. You can take up to 100 pictures in a row in this mode if your memory card has sufficient storage space. Choose Continuous by following Steps 1-3 above.

■ **Continuous—Electronic (Hi).** This is a special mode that's available when you choose the V1 or J1's Electronic (Hi) Shutter mode. You can take still photographs at rates of 10, 30, or 60 frames per second: If you want to change the frame rate, visit the Shutter Type entry in the Shooting menu. Scroll down to the Electronic (Hi) setting, then press the right directional button to reach the screen where you can specify frame rate.

■ **Self-timer.** You can use the self-timer as a replacement for a remote release, to reduce the effects of camera/user shake when the camera is mounted on a tripod or, say, set on a firm surface, or when you want to get in the picture yourself. You can specify delays of 2, 5, or 10 seconds. To choose a self-timer mode, just follow these steps:

1. Press the Self-timer button, located at the left edge of the camera's multi selector dial.

2. When the setting screen pops up, use the multi selector down button to scroll to 10s, 5s, or 2s, depending on the delay you want.

3. Press OK to confirm your setting. To turn off the self-timer, use Steps 1-2 and select OFF.

■ **Remote control.** The ML-L3 remote control can be used in two modes: Delayed Remote (shutter releases two seconds after you press the button on the ML-L3 IR remote); and Quick Response Remote (the shutter trips immediately when the button is pressed). To choose the Remote Control mode, use steps 1-3 above, and select the 2-second delayed remote, or quick response icons.

# Selecting an Exposure Mode

The V1 and J1's exposure modes include Programmed auto (or Program mode), Shutter-priority, Aperture-priority, and Manual exposure mode, known collectively as PSAM modes, for their initials. These are the modes that allow you to specify how the camera chooses its settings when making an exposure for greater creative control.

## Exposure Mode with Scene Auto Selector

The Nikon V1 and J1 can select an exposure mode for you from among a modest selection of automatically chosen settings. The available Scene modes the camera will opt for include Portrait, Landscape, Night Portrait, Close-Up, and

Auto (for other types of subjects). Unlike other cameras, you can't choose these Scene modes yourself.

1. Rotate the mode dial to the green Still Image mode icon.

2. Press the MENU button.

3. When the menu screen pops up, use the multi selector down button to scroll to Exposure Mode; then press the multi selector right button to select the entry.

4. When the Exposure Mode screen appears (see Figure 1.9), use the up/down buttons to select Scene Auto Selector, and then press the OK button to confirm.

The Scene modes chosen by the Scene Auto Selector take full control of the camera and make all the decisions for you. They are most useful while you're learning to use the camera, because you can just fire away. You'll end up with decent photos using appropriate settings, but your opportunities to use a little creativity (say, to overexpose an image to create a silhouette, or to deliberately use a slow shutter speed to add a little blur to an action shot) are minimal.

## Choosing an Advanced Exposure Mode

Your camera also has four semi-automatic and manual modes. To access these modes, just follow these steps:

1. Rotate the mode dial to the green Still Image mode icon.

2. Press the MENU button.

3. When the menu screen pops up, use the multi selector down button to scroll to Exposure Mode; then press the multi selector right button to select the entry.

4. When the Exposure Mode screen appears (see Figure 1.9), use the up/down buttons to select one of the four modes described next, and then press the OK button to confirm.

■ **P (Program).** This mode allows the camera to select the basic exposure settings, but you can still override the camera's choices to fine-tune your image, while maintaining metered exposure. Just press the zoom bar up or down to change from the recommended setting to an equivalent setting that produces the same exposure, but using a different combination of f/stop and shutter speed. This is called "Flexible Program" by Nikon. Press the zoom bar down to reduce the size of the aperture (going from, say, f/4 to f/5.6), so that the camera will automatically use a slower shutter speed.

Press the zoom bar up to use a larger f/stop, while automatically producing a shorter shutter speed that provides the same equivalent exposure as metered in P mode. The asterisk appears next to the P in the monitor so you'll know you've overridden the camera's default program setting. Your adjustment remains in force until you press the zoom bar up or down until the * is no longer displayed, or you switch to another exposure mode, turn the camera off, or the camera goes to sleep (enters standby mode).

■ **S (Shutter-priority).** This mode is useful when you want to use a particular shutter speed to stop action or produce creative blur effects. Choose your preferred shutter speed by pressing the zoom bar when the meter is active, and the camera will select the appropriate f/stop for you. (See Figure 1.10.)

■ **A (Aperture-priority).** Choose when you want to use a particular lens opening, especially to control sharpness or how much of your image is in focus. Specify the f/stop you want using the zoom bar when the meter is "awake" (tap the shutter release to activate the meter, if necessary), and the camera will select the appropriate shutter speed for you.

■ **M (Manual).** Select when you want full control over the shutter speed and lens opening. Press the zoom bar up to select a faster shutter speed/down to choose a slower shutter speed. Rotate the multi selector dial clockwise to choose smaller apertures, and counter-clockwise to select larger f/stops.

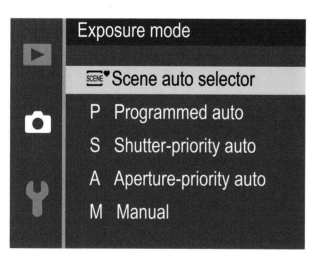

**Figure 1.9**
Choose an exposure mode.

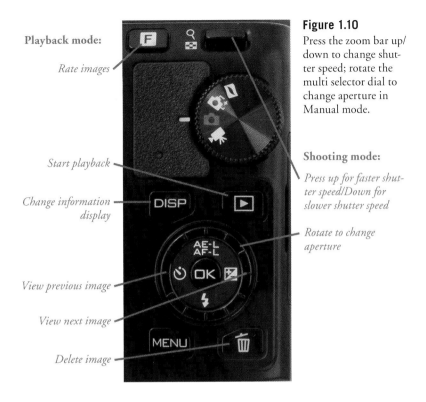

Playback mode:

*Rate images*

*Start playback*

*Change information display*

*View previous image*

*View next image*

*Delete image*

**Figure 1.10**
Press the zoom bar up/down to change shutter speed; rotate the multi selector dial to change aperture in Manual mode.

**Shooting mode:**
*Press up for faster shutter speed/Down for slower shutter speed*

*Rotate to change aperture*

# Choosing a Metering Mode

The metering mode you select determines how the V1 or J1 calculates exposure. The metering method is chosen for you when using Scene Auto Selector; the options described next are applied only when using PSAM exposure modes. You might want to select a particular metering mode for your first shots, although the default Matrix metering is probably the best choice as you get to know your camera. I'll explain when and how to use each of the three metering modes later. To change metering modes, just follow these steps:

1. Rotate the mode dial to the green Still Image mode icon.
2. Press the MENU button.
3. When the menu screen pops up, use the multi selector down button to scroll to Metering; then press the multi selector right button to select the entry.
4. When the Metering screen appears, use the up/down buttons to select one of the three modes described next, and then press the OK button to confirm.

- **Matrix metering.** The standard metering mode; the V1 or J1 attempts to intelligently classify your image and choose the best exposure based on readings from a broad span of the sensor area, using a database of thousands of patterns.

- **Center-weighted metering.** The camera meters the entire scene, but gives the most emphasis to the central area of the frame, measuring about 4.5mm.

- **Spot metering.** Exposure is calculated from a smaller 3mm spot, about 2 percent of the image area, using the center focus area, except when working with Face-priority AF mode (discussed shortly), which meters from a focus area spot closest to the center of the selected face.

# Choosing a Focus Mode

You can easily switch between automatic and manual focus modes using the menu system, as described several times previously in this chapter. You can select the autofocus mode (*when* the Nikon 1 camera measures and locks in focus) and autofocus pattern (*which* of the available autofocus points or zones are used to interpret correct focus). To specify when the camera locks in focus when using PSAM exposure modes (focus modes cannot be chosen when using automatic scene selection), follow these steps:

1. Rotate the mode dial to the green Still Image mode icon.
2. With the V1, press the down multi selector button, marked with the AF label. For the J1, press the MENU button and navigate to the Shooting menu (it's marked with a camera icon). Then scroll to Focus Mode, and press the multi selector right button to select the entry.
3. When the menu screen appears, use the multi selector up/down buttons to select one of the focus modes described next, and then press the OK button to confirm.

The five focus modes are described below. The first three are available when shooting stills; when shooting movies, only AF-S, AF-F, and M can be selected:

- **(AF-A) Automatic autofocus.** In this mode, the camera will select from AF-S or AF-C, depending on whether your subject is stationary or moving.

- **(AF-S) Single-servo autofocus.** This mode, sometimes called *single autofocus*, or AF-S, locks in a focus point when the shutter button is pressed down halfway. The focus will remain locked until you release the button or take the picture. This mode is best when your subject is relatively motionless.

- **(AF-C) Continuous-servo autofocus.** This mode, sometimes called *continuous autofocus*, or AF-C, sets focus when you partially depress the shutter button but continues to monitor the frame and refocuses if the camera or subject is moved. This is a useful mode for photographing sports and moving subjects. Note that in this mode, photos can be taken even if the camera has not quite locked in focus. The V1 and J1's hybrid focus system is very fast, so this won't happen very often.

- **(M) Manual focus.** In this mode, you can adjust focus manually. I'll describe the procedure next.

- **(AF-F) Full-time Autofocus.** This mode is available only when shooting movies, and replaces the AF-C and AF-A options. (Only AF-S, AF-F, or Manual focus can be selected in Movie mode.) When using AF-F, the camera focuses continuously, and images can be captured even if sharp focus is not quite locked in.

## Manual Focus

When you've set the camera to manual focus, you can adjust the zone of sharpness visually using the viewfinder or LCD. Just follow these steps:

1. **Activate focus guides.** Press the multi selector OK button to produce an enlarged view of the center of the frame, as shown in Figure 1.11. A focus scale and navigation window appear at the right of the screen. The outer box represents the entire frame, and the yellow box within it shows the relative portion of the frame currently being magnified.

**Figure 1.11**
Manual focus can be done using a zoomed-in view.

2. **Zoom in or out.** You can increase/decrease the amount of magnification by pressing the zoom bar up or down. The size of the yellow box changes to indicate the zoom magnification. Up to 10X magnification can be achieved.

3. **Position magnified area.** Although you can adjust the framing of the camera to relocate the magnified area, if you've mounted the camera on a tripod, you might want to "lock down" the setup. In that case, you can press the multi selector directional buttons to move the yellow box around in the navigation window, and, thus, the magnified area.

4. **Focus.** Rotate the multi selector dial to focus the image. The focus indicator bar at the right of the screen will show the approximate distance.

5. **Confirm focus.** Press the OK button to lock in focus when you're satisfied.

# Choosing the Focus Area Mode

You can specify *where* automatic focus is applied by choosing a focus area mode. The camera can detect the subject and select the area to focus, you can do that yourself, the camera can follow a subject as it moves, or it can be directed to look for human faces and focus on them:

1. Rotate the mode dial to the green Still Image mode icon.

2. Press the MENU button.

3. Scroll down to AF-Area Mode, and press the right button to produce the AF-area screen.

4. Use the multi selector up/down buttons to select one of the focus area modes described next, and then press the OK button to confirm.

5. If you want to activate Face-priority (a separate setting), return to the menu and scroll down one additional entry to Face-priority AF. Press the right multi selector button, select On, and press OK to confirm.

The focus area modes are described below.

- **Auto-area AF.** The camera chooses a focus point. This setting is especially useful for grab shots, because the camera can usually select the subject and lock in focus for you very quickly.

- **Single-point.** The camera focuses on a point you select. This mode is best for subjects that aren't moving when you know exactly where you want to focus. Press the multi selector OK button to reveal the focus area selection display, then position the focus area over your subject with the directional buttons. Press OK to confirm focus. Press the AE-L/AF-L button (the up directional button) to lock focus even when the shutter button is released.

- **Subject tracking.** The camera focuses on a point you select, then follows your subject as it moves. Press the multi selector OK button to reveal the focus area selection display, then position the focus area over your subject with the directional buttons. Press OK to confirm your subject. The camera will follow the subject, and then lock in focus on that subject when you press the shutter release halfway. Press the AE-L/AF-L button (the up directional button) to lock focus even when the shutter button is released.

- **Face-priority.** When active, the V1 or J1 looks for up to five human faces that are looking at the camera and places a double yellow border around the closest face. Press the shutter release button down halfway to lock focus on that face.

# Reviewing the Images You've Taken

The Nikon V1/J1 has a broad range of playback and image review options. (See Figure 1.10, shown earlier.)

- **View image.** Press the Playback button (marked with a white right-pointing triangle) at the center of the right edge of the back panel to display the most recent image on the LCD.

- **View additional images.** Press the multi selector left or right or rotate the multi selector dial to review additional images. Press right to advance to the next image, or left to go back to a previous image.

- **Change information display.** Press the DISP button to change among overlays of basic image information or detailed shooting information. I'll show you the photo information screens in the next chapter.

- **Change magnification.** Press the zoom bar up or down to zoom in and out of an image. A thumbnail representation of the whole image appears in the lower-right corner with a yellow rectangle showing the relative level of zoom. At intermediate zoom positions, the yellow rectangle can be moved around within the frame using the multi selector directional buttons.

- **See thumbnail versions.** When viewing an image full screen, pressing the zoom bar down produces thumbnail views with 4, 9, or 72 images per screen, or a calendar view. Pressing the zoom bar up again while in thumbnail view reduces the number of thumbnails until you reach the full screen display, where zooming begins again. While viewing thumbnail "contact sheets," you can use the multi selector directional buttons to move from one thumbnail to another. Press the OK button to view the selected image in full size. I'll explain more about using thumbnails and calendar view (retrieving all pictures taken on a certain date) in Chapter 2.

■ **Rate your images.** Press the F button, located at the top of the back panel next to the AE-L/AF-L button, to apply one to four stars. You can use these ratings to sort and search for images later, or mark them for deletion.

■ **Delete current image.** Press the Trash button to delete the currently displayed image.

■ **Exit image review.** Press the Playback button again, or just tap the shutter release button to exit playback view.

# Using the Flash

The V1 uses the optional SB-N5 flash unit; the J1 has a flash built-in. Using either is easy enough to work with that you can begin using them right away, either to provide the main lighting of a scene or as supplementary illumination to fill in the shadows. Refer to Chapter 5 for instructions on how to use either flash.

# Transferring Photos to Your Computer

The final step in your picture-taking session will be to transfer the photos you've taken to your computer for printing, further review, or image editing. Your Nikon 1 camera allows you to print directly to PictBridge-compatible printers and to create print orders right in the camera, plus you can select which images to transfer to your computer. I'll outline those options in Chapter 3.

I always recommend using a card reader attached to your computer to transfer files, because that process is generally a lot faster and doesn't drain the camera's battery (especially important with the J1, which has a much smaller battery than the V1). However, you can also use a cable for direct transfer, which may be your only option when you have the cable and a computer, but no card reader (perhaps you're using the computer of a friend or colleague, or at an Internet café).

To transfer images from the camera to a Mac or PC computer using the USB cable:

1. Turn off the camera.
2. Pry back the cover that protects the USB port on the left side of the V1 camera, and on the right side of the J1 (when held in the shooting position), and plug the USB cable furnished with the camera into the USB port. (See Figure 1.12, which shows the V1's port.)

3. Connect the other end of the USB cable to a USB port on your computer.
4. Turn on the camera. The operating system itself, or installed software such as Nikon Transfer or Adobe Photoshop Elements Transfer usually detects the camera and offers to copy or move the pictures. Or, the camera appears on your desktop as a mass storage device, enabling you to drag and drop the files to your computer.

To transfer images from a memory card to the computer using a card reader:

1. Turn off the camera.
2. Open the memory card door and extract the Secure Digital card.
3. Insert the memory card into your memory card reader. Your installed software detects the files on the card and offers to transfer them. The card can also appear as a mass storage device on your desktop, which you can open and then drag and drop the files to your computer.

**Figure 1.12**
Plug the USB cable into the port.

USB port

# Chapter 2

# Nikon V1/J1 Roadmap

You should find this roadmap of the functions of the V1/J1's controls more useful than the tiny black-and-white drawings in the manual packed with the camera, which has dozens of cross-references that send you on an information scavenger hunt through dozens of pages. Everything you need to know about the controls themselves is here. You'll find descriptions of menus and settings in Chapters 3 and 4.

## Nikon V1/J1: Front View

Figure 2.1 shows a front view of the Nikon V1/J1 from a 45-degree angle. The main components you need to know about are as follows:

- **AF-assist illuminator/Red-eye reduction/Self-timer lamp.** This LED provides a blip of light shortly before a flash exposure to cause the subjects' pupils to close down, reducing the effect of red-eye reflections off their retinas. When using the self-timer, this lamp also flashes to mark the countdown until the photo is taken. It can also illuminate to provide assistance for the camera's autofocus mechanism at fairly close distances. The lamp is located on the opposite side of the Nikon J1.

- **Stereo Microphones.** These record audio during movie shooting, and are located right and left of the lens mount (both of the V1's microphones are visible in the figure; the J1's other mic is located on the side not shown).

- **USB/HDMI port cover (J1 only).** This flip-back cover protects the USB and HDMI ports of the J1. (The V1 has a similar cover on its opposite side for USB, HDMI, and an additional stereo microphone jack.)

- **DC power port.** Connect the optional AC adapter to the battery compartment through this opening.

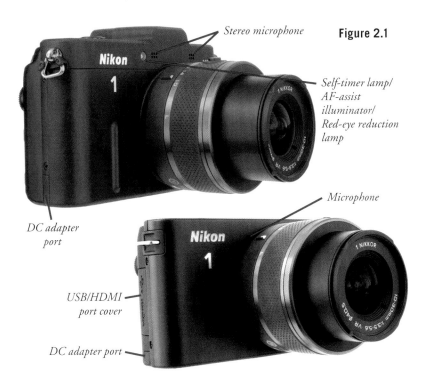

*Stereo microphone*

**Figure 2.1**

*Self-timer lamp/
AF-assist
illuminator/
Red-eye reduction
lamp*

*Microphone*

*DC adapter
port*

*USB/HDMI
port cover*

*DC adapter port*

Figure 2.2 shows a front view of the Nikon V1/J1 from the other side. The controls here include:

- **Lens release button.** Press this button to unlock the lens, then rotate the lens away from the shutter release button to dismount your optics.

- **Port cover (V1 only).** The cover protects the USB, HDMI, and external stereo microphone ports when not in use.

- **Infrared receiver.** This IR sensor receives a signal from the optional Nikon ML-L3 infrared remote control when in front of the camera (say, when you want to get in the picture yourself). With the V1, a second IR sensor is on the back panel of the camera.

- **Neck strap eyelet.** Fasten the neck strap of your choice here.

**Figure 2.2**

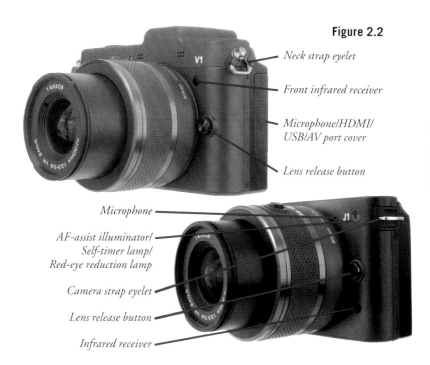

Neck strap eyelet

Front infrared receiver

Microphone/HDMI/
USB/AV port cover

Lens release button

Microphone

AF-assist illuminator/
Self-timer lamp/
Red-eye reduction lamp

Camera strap eyelet

Lens release button

Infrared receiver

# The Nikon V1/J1's Back Panel

The back panel of the Nikon V1/J1 bristles with different controls, buttons, and knobs. That might seem like a lot of controls to learn, but you'll find that it's a lot easier to press a dedicated button and spin a dial than to jump to a menu every time you want to access one of these features. You can see the controls clustered along the top edge of the back panel in Figure 2.3 and those on the right side in Figure 2.4. The key buttons and components and their functions are as follows:

- **Electronic viewfinder window (V1 only).** You can frame your composition by peering into the viewfinder. It's surrounded by a soft rubber frame that seals out extraneous light when pressing your eye tightly up to the viewfinder, and it also protects your eyeglass lenses (if worn) from scratching.

- **Eye sensor (V1 only).** The V1 can alternate between showing live views, playback display, or menus on either the back-panel LCD or the electronic viewfinder. Either display is activated by tapping the shutter release. Then, when you bring the camera to your eye, the sensor inside the eyepiece detects that orientation and switches the display from the LCD to the

*Pop-up flash release button (J1 only)*

**Figure 2.3**

*Multi accessory port (V1 only)*   *Eye sensor (V1 only)*   *Electronic viewfinder (V1 only)*   *Diopter correction wheel (V1 only)*   *LCD screen*

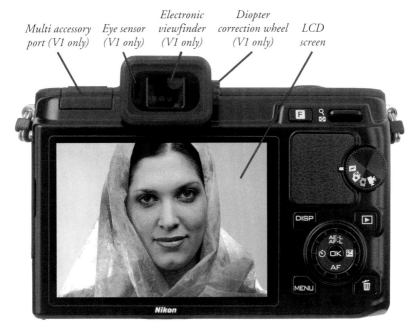

electronic viewfinder. If you prefer to use the electronic viewfinder only, press the DISP button northwest of the multi selector until the LCD screen goes blank.

■ **Multi accessory port cover (V1 only).** This removable cover protects the accessory connector used to attach the optional flash and GPS units.

■ **Pop-up flash release button (J1 only).** Unlike the V1, the J1 has a built-in flash, and this button can be used to elevate it. (See inset.)

■ **Diopter correction wheel (V1 only).** Rotate this to adjust the diopter correction for your eyesight.

■ **LCD screen.** The V1 can alternate views between this LCD and the electronic viewfinder; with the J1, the images and menus are always displayed on the LCD.

You'll be using the buttons to the right of the LCD quite frequently, so learn their functions now. The two cameras share these buttons with one function exception.

- **F (Feature) button.** This button performs different functions, depending on whether you're using Still Image, Movie, Motion Snapshot, or Playback camera modes:

  - **Still Image mode.** Press to produce a screen that allows you to choose Mechanical, Electronic, or Electronic (Hi) shutter operation.

  - **Movie mode.** Press the F button to pop up a screen that lets you toggle between HD movie and Slow Motion movie modes, as described in Chapter 6.

  - **Motion Snapshot mode.** The F button produces a screen that allows you to choose from Beauty, Waves, Relaxation, and Tenderness themes.

  - **Playback mode.** When reviewing pictures, the F button pops up a scale that allows you to embed a star rating in an image's file, ranging from 0 stars to 5 stars, plus a "trash" (negative) star you can apply to mark an image for deletion.

**Figure 2.4**

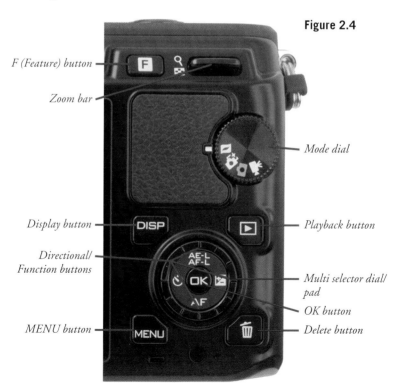

F (Feature) button

Zoom bar

Mode dial

Display button

Playback button

Directional/
Function buttons

Multi selector dial/
pad

OK button

MENU button

Delete button

■ **Zoom bar.** This bar can be pressed up or down to zoom in and out of an enlarged image, or to increase/decrease the number of thumbnail images shown on the screen during review. In shooting mode, the zoom bar is used to adjust exposure options, such as shutter speed or f/stop.

■ **Mode dial.** Changes from Motion Snapshot, Smart Photo Selector, Still Image, and Movie modes. I'll explain all these photo modes in Chapter 4, and describe how and when to use them.

■ **MENU button.** Summons/exits the menu shown on the display. When you're working with submenus, this button also serves to exit a submenu and return to the main menu.

■ **OK button.** The button in the center of the multi selector can be pressed to choose a highlighted selection in a menu and to confirm choices.

■ **Playback button.** Shows most recently shot image. When viewing most menu items on the LCD, pressing this button produces a concise Help screen with tips on how to make the relevant setting.

■ **Display (DISP) button.** Use this button to change the amount and type of information shown on the screen in both Playback and Shooting modes. With the V1, you can select a display mode for the LCD and electronic viewfinder separately.

■ **Multi selector.** This joypad-like button can be shifted up, down, side to side, and diagonally for a total of eight directions, or rotated. In navigational mode, it can be used for several functions, including AF point selection, scrolling around a magnified image, trimming a photo, or setting white balance correction. Within menus, pressing the up/down arrows moves the on-screen cursor up or down; pressing toward the right selects the highlighted item and displays its options; pressing left cancels and returns to the previous menu.

■ **Directional/Function buttons.** The N, S, E, and W positions on the multi selector each have secondary functions in shooting (non-Playback) mode. The up button can be used to lock focus/and or exposure; the right button produces an LCD pop-up that dials in exposure compensation when working in Program, Aperture-priority, or Shutter-priority modes (but not automatic scene selection or manual exposure). The left button is used to select a self-timer or remote control mode. With the V1, the down button lets you specify an autofocus mode (AF-S, AF-C, AF-A, or M). On the J1, the down button produces the flash mode adjustment screen, and autofocus modes are chosen from the menu system instead.

■ **Delete button.** In Playback mode, press once to delete the picture currently being reviewed. Press a second time to confirm the deletion, or the Playback button to chicken out and cancel.

# What's on the Screen?

If you're accustomed to working with a digital SLR or a point-and-shoot digital camera, you'll find that the informational display on the Nikon V1 is probably a bit different from what you're used to. It has two complete electronic viewing systems, each used to show you everything you need to see to operate your camera, from a live view preview of your frame before you take the picture, to the menus used to make settings, to the picture review that displays your photos after they've been taken.

The two separate viewing systems (internal electronic viewfinder and back-panel LCD) can both be active at the same time, and the V1 will alternate between them, depending on whether the camera's eye sensors indicate that you have brought the camera to your eye, or are using it at arms' length. Both are always in the same mode simultaneously—shooting mode, playback mode, or menu mode—but the amount and type of information they display may be different. You can choose the data shown for each using the DISP button, as described next.

- **Shooting mode.** In shooting mode, there are three different displays for the back-panel LCD, and (with the V1) two for the internal electronic viewfinder. You can cycle among them by pressing the DISP on the back of the camera. Nikon V1 owners should note that the LCD and EVF can be showing different data displays. Each is set when you press the DISP button while using that particular viewing system (LCD or EVF).

  - **LCD.** When using the back-panel LCD on the V1 and J1, pressing the DISP button repeatedly cycles among a simplified display (see Figure 2.5, top), a detailed display (Figure 2.5 middle), and a grid display (Figure 2.5 bottom, and described below). The V1 also has a fourth "display" for the back panel: an LCD Off condition (nothing shown on the LCD); V1 owners must use the internal EVF to preview an image.

  - **Internal EVF (V1 only).** Pressing the DISP button cycles only between the simplified display and detailed display, and can activate a grid display in the EVF (all three variations are identical to what you see in Figure 2.5). There is no option to turn the internal EVF off completely, except, of course, when you remove the V1 from your eye.

  - **Grid display.** The grid display I mentioned earlier is an option available for any of the shooting mode views. The grid divides the frame into quarters horizontally and vertically with an overlay. It's not a "Rule of Thirds" layout, and so is of more use in checking the alignment of horizontal lines (such as the horizon) and vertical lines as you compose the image. Activate the grid in the Setup menu, using the Grid Display entry to turn it On or Off.

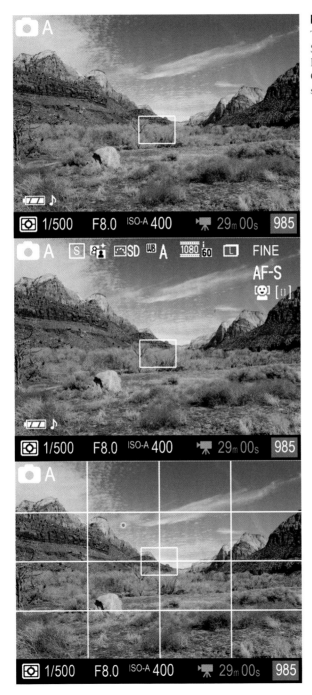

**Figure 2.5**
Top to bottom:
Simplified,
Detailed,
Optional Grid
shooting displays.

■ **Picture Review/Playback mode.** When reviewing your images after they've been taken, the DISP button can be used to cycle among three different views: Picture only (just a "clean" image with no information overlay; this allows you to view your photo with no distractions); simple photo info (see Figure 2.6, top), with basic data arrayed along the bottom and upper left/right corners of the image); and detailed photo information (see Figure 2.6, bottom), which displays a reduced size thumbnail of your image along with complete shooting information, including a histogram display.

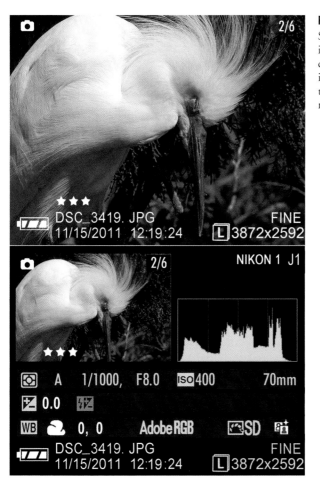

**Figure 2.6**
Simple photo information (top), detailed photo information (bottom), in playback mode.

As in shooting mode, with the V1 you can have different playback displays in the EVF and back-panel LCD. I like to set my V1 camera to show the plain vanilla image in the EVF (which has a higher resolution and is less affected by ambient light), and the detailed photo info display on the LCD. In some ways, it's the best of two worlds.

■ **Menu mode (V1 only).** When viewing menus, the V1 shows the exact same image in the EVF and on the LCD, and the DISP button has no effect.

# Playing Back Images

Although I touched on playback display of images in Chapter 1, the next section will provide more detailed information.

■ **Start review.** To begin review, press the Playback button located northeast of the multi selector pad on the back of the camera. The most recently viewed image will appear on the LCD.

■ **Zoom in and out.** To zoom in or out, press the zoom bar up (zoom in) or down (zoom out). While zoomed, you can use the directional buttons to move the enlarged area around the screen, as highlighted in yellow in an inset navigation window. (See Figure 2.7, top.) You can continue zooming in to a maximum of approximately 25X. The navigation window vanishes after a few seconds, leaving you with a full-screen view of the zoomed portion of the image.

■ **Detect faces.** While zoomed in, if Face-priority AF is activated the camera may detect up to 4 faces, indicated by white borders in the navigation window. Rotate the multi selector dial to move highlighting to the individual faces.

■ **Move back and forth.** To advance to the next image, press the right edge of the multi selector pad; to go back to a previous shot, press the left edge. You can also rotate the multi selector dial clockwise (next image) or counterclockwise (previous image). When you reach the beginning/end of the photos in your folder, the display "wraps around" to the end/beginning of the available shots.

■ **View thumbnail images.** When in full frame view, pressing the zoom bar down will change the display to four, nine, or 72 reduced-size thumbnail images (as shown in Figure 2.7, bottom), followed by a calendar view that shows images grouped by the date they were shot.

**Figure 2.7** Zoomed view, with navigation box (top); four, nine, and 72 thumbnails (bottom).

- **See different types of data.** To change the type of information about the displayed image that is shown, press the DISP button repeatedly to cycle through the options.
- **Remove images.** To delete an image that's currently on the screen, press the Trash button once, then press it again to confirm the deletion. To select and delete a group of images, use the Delete option in the Playback menu to specify particular photos to remove.
- **Cancel playback.** To cancel image review, press the Playback button again, or simply tap the shutter release button.

## Working with Calendar View

Once in calendar view, you can sort through images arranged by the date they were taken. This feature is especially useful when you're traveling and want to see only the pictures you took in, say, a particular city on a certain day.

- **View dates and images taken on that date.** A yellow highlight box appears around a selected date in the date list calendar, as shown in Figure 2.8.
- **Change dates.** Use the multi selector keys or rotate the multi selector dial to move through the date list.
- **View a date's images.** Press the OK button to view the first picture taken on the selected date. You can then press the multi selector left/right buttons to advance or move back among the stored images starting from that image. Press the zoom bar up to return to the 72-image thumbnail display.
- **Other functions.** Once you begin viewing images starting with a particular calendar date, you can perform the other functions described in the viewing thumbnails section, including rating images, deleting images, or exiting image review.

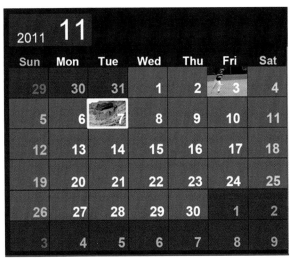

**Figure 2.8**
Calendar view allows you to browse through all images on your memory card taken on a certain date.

# Going Topside

The top surface of the Nikon 1 cameras have their own frequently accessed components. Figure 2.9 shows the top panel of the Nikon V1; the Nikon J1 is very similar except that the multi-accessory port is replaced by an internal pop-up flash unit, and it lacks the housing for the electronic viewfinder.

■ **Multi-accessory port (V1 only).** Slide the SB-N5 electronic flash or GP-N100 GPS unit into this mount. If you have the AS-N1000 adapter, you can mount other accessories, such as the ME-1 stereo microphone on top of the camera. There's more on using electronic flash in Chapter 5.

■ **Focal plane indicator.** This indicator shows the *plane* of the sensor, for use in applications where exact measurement of the distance from the focal plane to the subject is necessary. (These are mostly scientific/close-up applications.)

■ **Speaker.** Your camera emits sounds, such as your movie audio track during playback, through this device.

■ **Shutter release button.** Partially depress this button to activate the exposure meter, lock in exposure, and focus. Press all the way to take the picture. Tapping the shutter release when the camera has turned off the autoexposure and autofocus mechanisms reactivates both. When a review image is displayed on the display, tapping this button removes the image from the display and reactivates the autoexposure and autofocus mechanisms.

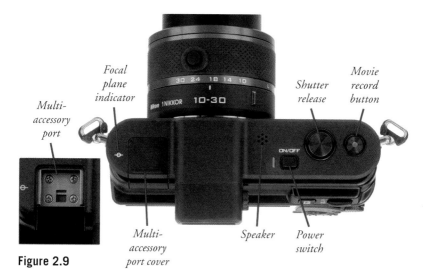

**Figure 2.9**

■ **Power switch.** Press this button to turn the camera on or off. The green LED to the left of the button will glow briefly as the camera powers up or down.

■ **Movie record button.** When the mode dial is set to Movie mode or Still Image mode (with the V1 only), press once to begin recording a video clip; press again to stop recording. A recording indicator, elapsed time, and amount of time remaining appear on the display. You'll find more about movie making in Chapter 6.

# Lens Components

As I write this, there are four lenses available for the Nikon 1 system. Pictured at left in Figure 2.10 is the Nikkor 10-100mm zoom lens, and at right is the Nikkor 30-110mm zoom. The 10-100mm has some features not found in its smaller sibling, because it has been optimized for movie shooting. Conversely, the 30-110mm lens is a general-purpose optic that has a few features you won't see on the larger lens.

■ **Lens hood.** The hood serves to shield the lens from extraneous light outside the picture area, and also protects the front glass element from knocks and dings. For that reason alone, I never shoot without a hood.

■ **Lens hood alignment indicators.** A dot on the outer edge of the lens is lined up with a second dot on the lens hood, and the hood rotated to a third position where it locks in place.

■ **Power zoom button.** The 10-100mm lens has a power zoom button, providing a smooth zoom that's especially useful while shooting movies. (Although zooming within a shot should be used carefully, or in moderation.) Press the T position to zoom in, and the W to zoom back out. The harder you press, the faster the zoom.

■ **Lens focal length lock switch.** The 10-100mm lens retracts automatically when the V1 camera is powered down, making the camera/lens more compact. If you want the lens to remain extended so you can begin shooting more quickly when the camera is powered back up, move this switch to the lock position.

■ **Lens hood bayonet.** Lenses like the two shown use this bayonet to mount the lens hood. Such lenses generally will have a dot on the edge showing how to align the lens hood with the bayonet mount.

■ **Filter thread.** Most lenses have a thread on the front for attaching filters and other add-ons, including non-bayoneting lens hoods.

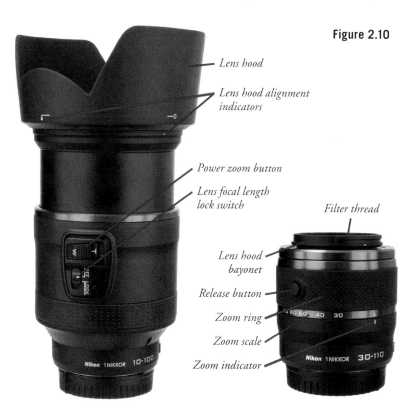

**Figure 2.10**

Lens hood

Lens hood alignment
indicators

Power zoom button

Lens focal length
lock switch

Filter thread

Lens hood
bayonet

Release button

Zoom ring

Zoom scale

Zoom indicator

- **Zoom ring.** Turn this ring to change the zoom setting. Lenses that use a power zoom lack this ring, and cannot be zoomed manually.
- **Zoom scale/zoom indicator.** These markings on manually zoomable lenses show the current focal length selected. Oddly enough, when using a power zoom lens, you never know the actual focal length, because the zoom setting is not shown on either camera display. After you've taken the shot, the lens focal length is shown in the detailed picture display, however.
- **Release button.** Some lenses can be manually retracted and extended. Press this button to allow the zoom ring to be rotated to the retract/extend positions.

The back end of a lens intended for use on a Nikon 1 camera has other components that you seldom see (except when you swap lenses), but still should know about:

- **Lens bayonet mount.** This is the mounting mechanism that attaches to a matching mount on the camera.
- **Electronic contacts.** These metal contacts pass information to matching contacts located in the camera body allowing a firm electrical connection so that exposure, distance, and other information can be exchanged between the camera and lens.
- **Lens mount alignment indicator.** Match this raised ridge on the lens barrel with the index dot on the camera body to mate the lens with the body when changing optics.

# Underneath Your Nikon V1 or J1

There's not a lot going on with the bottom panel of your Nikon V1/J1. You'll find the battery compartment access door, and a tripod socket, which secures the camera to a tripod. The socket accepts other accessories, such as quick release plates that allow rapid attaching and detaching the camera from a matching platform affixed to your tripod.

# Chapter 3

# Playback and Shooting Menu Settings

The Playback and Shooting menus determine how the V1/J1 displays images on review, and how it uses many of its shooting features to take a photo. You'll find the Setup menu options in Chapter 4.

## Anatomy of the Nikon V1/J1's Menus

Press the MENU button, located to the right of the viewfinder, to access the menu system. The most recently accessed menu will appear. Navigating among the various menus is easy and follows a consistent set of rules.

- **Access menus.** Press the MENU button to display the main menu screens.

- **Navigate among top-level menus.** Use the multi selector's left/right/up/down buttons to navigate among the menu entries to highlight your choice. Moving the highlighting to the left column lets you scroll up and down among the three top-level menus. From the top in Figure 3.1, they are Playback, Shooting, and Setup.

- **Choose menu entry.** A highlighted top-level menu's icon will change from gray and white to yellow highlighting. Use the multi selector's right button to move into the column containing that menu's choices, and the up/down buttons to scroll among the entries. If more than one screen full of choices is available, a scroll bar appears at the far right of the screen, with a position slider showing the relative position of the currently highlighted entry.

- **Select options.** To work with a highlighted menu entry, press the OK button in the center of the multi selector, or just press the right button on the multi selector. Any additional screens of choices will appear. You can move among them using the same multi selector movements.

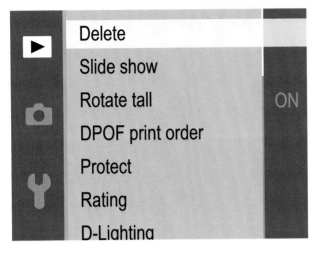

Delete

Slide show

Rotate tall                                    ON

DPOF print order

Protect

Rating

D-Lighting

**Figure 3.1**
The multi selec-
tor's navigational
buttons are used
to move among
the various menu
entries.

- **Confirm choice.** You can confirm a selection by pressing the OK button or, frequently, by pressing the right button on the multi selector once again.
- **Exit when done.** Pressing the multi selector left button usually backs you out of the current screen, and pressing the MENU button again usually does the same thing. You can exit the menu system at any time by tapping the shutter release button.
- **Menus redux.** The Nikon V1/J1 "remembers" the top-level menu and specific menu entry you were using (but not any submenus) the last time the menu system was accessed, so pressing the MENU button brings you back to where you left off.

## Playback Menu

The Playback menu has ten entries where you select options related to the display, review, editing, and printing of the photos you've taken (and are not available if your memory card is blank). The first seven choices are shown in Figure 3.1; the last three, Resize, Crop, and Edit Movie don't appear until you scroll to the bottom.

- Delete
- Slide Show
- Rotate Tall
- DPOF Print Order
- Protect

- Rating
- D-Lighting
- Resize
- Crop
- Edit Movie

# Delete

Choose Delete Selected Images, Select Images By Date, Delete All Images, and Discard. (See Figure 3.2, top.)

1. **View images.** Use the multi selector left/right cursor keys or the dial to scroll among the available images. (See Figure 3.2, middle.)

2. **See movies and still pictures.** Movie clips will have graphics representing sprocket holes displayed on either side of their thumbnails. Movie clips you have trimmed will have a scissors icon shown at the upper-left corner of the thumbnail.

3. **Mark images for deletion.** When you highlight an image or movie you think you might like to delete, press the up button to mark (with a trash can icon) or the down button to unmark.

4. **Zoom in to examine image.** Press and hold the zoom bar up to temporarily see the highlighted image in a larger size.

5. **Delete and Confirm.** When you've finished marking images to delete, press OK. A final screen will appear asking you to confirm the removal of the image(s). Choose Yes to delete the image(s) or No to cancel deletion, and then press OK. If you selected Yes, then you'll return to the Playback menu; if you chose No, you'll be taken back to the selection screen to mark/unmark images.

6. **Exit.** To back out of the selection screen, press the MENU button or tap the shutter release button.

In the main Delete screen you can also choose Select Images by Date. Just follow these steps:

1. **See available dates.** The Select Images by Date screen will show you a thumbnail of the first movie/still captured on a particular date. (See Figure 3.2, bottom.)

2. **See images for that date.** While you can mark a date and all its images for deletion from this screen, if you like you can press the zoom bar down to view all the images taken on that date in a scrollable list.

3. **Zoom in to examine image.** From the screen that appears, press and hold the zoom bar up to temporarily see a highlighted image for that date in a larger size.

4. **Return to date selection screen.** When you're satisfied with deleting all the images for that date, press OK to mark them all for deletion. You'll be returned to the date selection screen with a check mark placed next to the thumbnail for that date. You can also press the zoom bar's down button to return to the screen without marking the images.

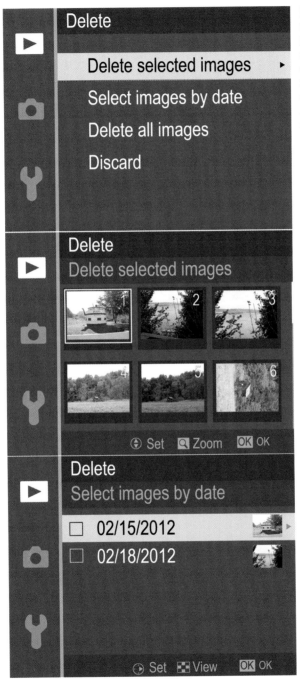

**Figure 3.2**
Choose which images to remove (top); delete specific selected images (middle); remove only images taken on a certain date (bottom).

5. **Mark dates for deletion.** You can review other dates as described in Steps 2-4, or simply mark dates for deletion from this screen by pressing the right multi selector button. Dates scheduled for erasure are indicated with a checked box.

6. **Delete and Confirm.** When you've finished marking dates to delete, press OK. A final screen will appear asking you to confirm the removal of the image(s). Choose Yes to delete the image(s) or No to cancel deletion, and then press OK. If you selected Yes, then you'll return to the Playback menu; if you chose No, you'll be taken back to the selection screen to mark/unmark images.

7. **Exit.** To back out of the selection screen, press the MENU button or tap the shutter release button.

Your final two choices from the main Delete screen are Delete All Images, which removes all the images from your memory card, and Discard. Discard removes all images you've marked with the Trash icon rating in the Rating Pictures menu.

## Slide Show

The V1/J1's Slide Show feature is a convenient way to review images one after another, without the need to manually switch between them.

1. **Access slide show.** In the Playback menu, navigate to Slide Show and press the right navigational button. The screen shown in Figure 3.3, top, appears.

2. **Select from the eight image/movie types available.** If no images or movies are available of the type you specify, slide show setup will stop until you select an option that has available images. Only the first six are shown on the screen initially; you'll need to scroll down to see the last two, By Rating, and Face-priority. Your choices are:

   ■ **All Images.** All the movies and still images of any type on your memory card will be included.

   ■ **Still Images.** Only still photographs are included in the slide show.

   ■ **Movies.** Your slideshow will display all movie clips.

   ■ **Motion Snapshot.** The slide show includes only the short movie part of your motion snapshots, and skips the photographs.

   ■ **Select Images by Date.** A calendar, like the one shown in Figure 3.3, middle, appears. Use the multi selector buttons to highlight a date and press OK. Only the images taken on that date will be included in your slide show.

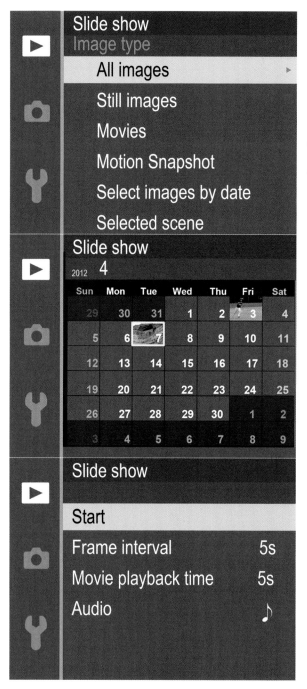

**Figure 3.3**
Choose which type of stills and movies to include in your slide show (top); select images taken on a particular date (middle); specify other parameters for your slide show (bottom).

- **Selected Scene.** Choose to display only the images that the Auto Scene Selector has selected to take using a particular scene classification. You can select from Auto, Portrait, Landscape, Night Portrait, and Close-ups.

- **By Rating.** This is the closest you can come to hand-picking which photos to display in your slide show. Choosing By Rating displays a screen with five rows of stars, from five stars to one star, with a checkbox next to each. Highlight any row and press the right directional button to mark or unmark that rating. You can choose any combination of ratings you like: view only five star pictures, both five star and four star images, or, if you're feeling quirky, choose to see five star *and* one star images for a best shot/worst shot comparison. If you carefully rate your images during playback review, you can effectively choose which ones will be included in a slide show.

- **Face-priority.** If you hanker to view all your people shots in one sitting, this option will include only shots in which the V1 or J1 detected faces (if Face-priority was active during shooting).

3. **Advance to setup screen.** Once you've selected which images to include, you'll be taken to the setup screen shown in Figure 3.3, bottom. The next steps shows you how to finish setting up your slide show.

After choosing the images/movies to be displayed, follow these steps to specify the other parameters required, and start your show.

1. **Choose a still frame interval.** Highlight the Frame Interval choice, press the right directional button, and select from 2, 3, 5, or 10 seconds.

2. **Select movie playback time.** Choose how much of the movie will be displayed before the slide show continues to the next still or movie clip. Your choices are:

   - **Same as Frame Interval.** The slide show will display only the first 2, 3, 5, or 10 seconds of a movie clip, corresponding to the interval you selected for still frames.

   - **10s/15s.** Display the first 10 seconds or 15 seconds of each movie clip (respectively), regardless of what setting you've selected for the still frame interval. Use to allow your movie clips to run a bit longer than the still frames.

   - **ALL.** This selection tells the V1/J1 to play each movie clip to the bitter end.

3. **Audio.** This choice controls the sound played with your slide show.
   - **Mute.** No sound is played during the slide show for still images or movies.
   - **Background Track 1/2/3.** Musical background music is played for all media.
   - **Movie Sound Tracks.** Only movie audio (if any was recorded) will play back. Still images and motion snapshots will be muted.
4. **Begin Slide Show.** Highlight Start and press the right directional button to begin your slide show.

## Viewing the Slide Show

Here are your options (unlike movie playback, on-screen display of the available controls isn't shown):

- **Pause.** Press the OK button to pause the show. Press a second time to resume.
- **Forward/Reverse.** Press the left directional button to return to the previous image/movie. Press the right directional button to skip to the next frame.
- **Adjust Volume.** Press the zoom bar up to increase the volume, down to reduce volume.
- **Exit Show.** Just tap the shutter release to return to shooting mode.
- **Replay.** When finished, a screen pops up for restarting (Resume), entering new parameters for playback, or exiting the slide show.

# Rotate Tall

When you rotate the V1 or J1 to photograph vertical subjects in portrait (tall), rather than landscape (wide) orientation, you probably don't want to view them tilted onto their sides later on, either on the camera display or within your image viewing/editing application on your computer. The camera embeds in the image file orientation information, which can be used to automatically rotate images when they are displayed on the camera's monitor, or in your image-editing/cataloging software. You can also let the images display in non-rotated fashion. Rotation works only if you've set Auto Image Rotation to On in the Setup menu, as described in Chapter 4. This menu choice deals only with whether the image should be rotated when displayed on the *camera LCD (V1/J1)* or *electronic viewfinder (V1).*

# DPOF Print Order

The Nikon V1 and J1 support the DPOF (Digital Print Order Format) that is now almost universally used by digital cameras to specify which images on your memory card should be printed, and the number of prints desired of each image. Photo labs and PictBridge printers are equipped to read this data and make prints from your memory card.

1. **Choose DPOF Print Order.** In the Playback menu, navigate to the DPOF Print Order selection and press the right directional button. You'll see a screen that allows you to select/set the images to be printed, or reset (which unselects any images currently selected).

2. **View images.** Use the multi selector left/right buttons or dial to move among the available images.

3. **Evaluate image.** When you highlight an image you want to print, press the zoom bar upward to temporarily enlarge that image so you can evaluate it further.

4. **Set number of prints.** To mark an image for printing, press the multi selector up and down buttons to choose the number of prints you want, up to 99 per image.

5. **Reduce prints.** To unmark an image for printing, highlight and press the down button until the number of prints reaches zero.

6. **Confirm.** When you've finished marking images to print, press OK.

7. **Add data.** A final screen will appear in which you can request a shooting data imprint (shutter speed and aperture) or imprint date (the date the photos were taken). When a box is marked, the imprint information for that option will be included on *all* prints in the print order.

8. **Finish.** Press OK when done.

# Using the PictBridge Menu

The PictBridge menu is not accessible from the Playback menu. It appears when the V1 or J1 is connected to a PictBridge-compatible printer. It uses a procedure almost identical to the one described above, but additional options for selecting by date, making thumbnail index prints of the first 256 pictures on the card, and additional options such as Page Size, Number of Copies, Print Border, Print Time Stamp, or Crop (available with printers that support cropping; a dialog box appears with a cropping frame that can be changed in size with the zoom bar).

## Protect

This choice allows you to view pictures on your memory card and mark them as Protected to keep them from being accidentally deleted. The Protect attribute is also used by other applications. For example, if you have an Eye-Fi card inserted in the camera, that card can be set using the Eye-Fi center software to either upload *all* photos you take, or only those that have been marked with Protect.

## Rating

When reviewing pictures during Playback, the F button pops up a scale that allows you to embed a star rating in an image's file, ranging from 0 stars to 5 stars, plus a "trash" (negative) star you can apply to mark an image for deletion. You can also apply ratings manually using this menu entry.

## D-Lighting

This Playback menu option brightens the shadows of pictures that have already been taken by saving a retouched copy with the changes applied. When you select D-Lighting, you'll see an image selection screen similar to the ones offered by the Protect and other menu entries already discussed in this chapter. The screen works exactly the same way to choose an image, using the left/right directional buttons, the zoom bar up motion to temporarily zoom in, and the OK button to select the highlighted image for application of the effect.

At that point, the screen shown in Figure 3.4 appears. Use the up/down directional buttons to choose from Off and On. Press the OK button to save a

**Figure 3.4**
Choose the degree of D-Lighting to apply.

retouched copy in JPEG format. I'll explain D-Lighting in more detail and provide some examples in the Shooting Menu section under Active D-Lighting.

## Resize

This option creates smaller copies of the selected images, for e-mail or web pages.

1. **Navigate to Resize.** Press the MENU button, and navigate to Resize from the Playback menu, and then press the right button to access the Resize screen.

2. **Select new size.** You can specify a resolution/size for all the copies made. Select Choose Size and opt for 1.1M (1280 × 856 pixels), 0.6M (960 × 640 pixels), or 0.3M (640 × 424 pixels). Press OK to return to the Resize screen.

3. **Select images.** Scroll among the images with the left/right directional buttons or dial and mark still images for reduction using the up button. The down button unmarks any previously specified image.

4. **Confirm.** Press OK when finished marking images, and reply Yes to the Create Resized Copy/Copies? prompt.

## Crop

Creates trimmed copies of still images, chosen from among 3:2, 4:3, 1:1, and 16:9 proportions.

1. **Select your photo.** Choose Trim from the Playback menu. Scroll among the photos using the multi selector left/right buttons or dial, and press OK when the image you want to trim is highlighted.

2. **Choose your aspect ratio.** Rotate the multi selector dial to change from 3:2, 4:3, 1:1, and 16:9 aspect ratios.

3. **Crop in on your photo.** Press the zoom bar up or down to crop in and out on your picture. The pixel dimensions of the cropped image at the selected proportions will be displayed in the upper-left corner (see Figure 3.5) as you zoom. The current framed size is outlined in yellow.

4. **Move cropped area within the image.** Use the multi selector left/right and up/down buttons to relocate the yellow cropping border within the frame.

5. **Save the cropped image.** Press OK to save a copy of the image using the current crop and size, or press the Playback button to exit without creating a copy. Table 3.1 shows the trim sizes available.

**Figure 3.5**
The Crop feature allows in-camera cropping.

| Table 3.1 | Trim Sizes |
|---|---|
| **Aspect Ratio** | **Sizes Available** |
| 3:2 | 3424 × 2280, 2650 × 1704, 1920 × 1280, 1280 × 856, 960 × 640, 640 × 424 |
| 4:3 | 3424 × 2568, 2650 × 1920, 1920 × 1440, 1280 × 960, 960 × 720, 640 × 480 |
| 1:1 | 2650 × 2650, 1920 × 1920, 1440 × 1440, 960 × 960, 720 × 720, 480 × 480 |
| 16:9 | 3424 × 1920, 2650 × 1440, 1920 × 1080, 1280 × 720, 960 × 536, 640 × 360 |

# Edit Movie

Edit movies as you view them, pausing (using the down directional button) and clipping off portions from the beginning and/or end of any movie more than two seconds long to create an edited version.

1. **View the clip.** Press the OK button to begin playback, using the down button to pause and OK to resume. When you reach the first frame you want to keep, press the down button to pause.

2. **Trim from beginning.** Press the up directional button to delete all the frames that appear before the frame where you paused, and confirm by selecting Yes.

3. **Trim from the end.** Watch the movie until you reach the last frame you want to keep and then press the down button to pause. Then press the up button to trim, and choose Yes to confirm.

# Shooting Menu

The Shooting menu differs slightly, depending on whether the mode dial is set for Still Image mode or Movie mode. There are 27 entries (with the V1; 25 with the J1) in the Still Image mode version, and 15 in the Movie mode version. Appropriate flash entries are available only when you have the optional electronic flash mounted on the V1, or the J1's internal flash is elevated.

- Reset Shooting Options
- Exposure Mode
- Frame Rate (High Speed Movie mode only)
- Movie Settings (Movie Mode only)
- Image Quality
- Image Size
- Continuous
- Shutter Type (V1 only)
- Metering
- White Balance
- ISO Sensitivity
- Picture Control
- Custom Picture Control
- Color Space
- Active D-Lighting

- Long Exposure NR
- High ISO Noise Reduction
- Fade In/Fade Out
- Movie Sound Options
- Interval Timer Shooting
- Vibration Reduction
- Focus Mode (J1 only)
- AF-Area Mode
- Face-Priority AF
- Built-in AF Assist
- Flash Mode (When flash is mounted, V1 only.)
- Flash Control (When flash is mounted, V1 only.)
- Flash Compensation (When flash is mounted (V1) or raised (J1).)

## Reset Shooting Options

This entry returns the Shooting menu options to their default values, shown in Table 3.2.

## Exposure Mode

Use this menu item to specify how the camera chooses shutter speed and aperture. Your choices are Scene Auto Selector, Programmed auto (P), Shutter-priority auto (S), Aperture-priority auto (A), and Manual. (See Figure 3.6.)

## Table 3.2  Shooting Menu Defaults

| Option | Default | Option | Default |
|--------|---------|--------|---------|
| Exposure Mode | Scene Auto Selector | Long Exposure NR | On |
| Image Quality | JPEG Normal | Fade In/Fade Out | None |
| Image Size | 3872 × 2592 | Movie Sound Options | |
| Continuous | Single frame | Microphone | Auto sensitivity (A) |
| Shutter Type | Mechanical | Wind Noise Reduction | On |
| Electronic (Hi) | 10fps | Interval Timer Shooting | 00:01':00",001 |
| Frame Rate | 400fps | Vibration Reduction | Active/On |
| Movie Settings | 1080/60i | AF-Area Mode | Auto-Area |
| Metering | Matrix | Face-Priority AF | On |
| White Balance | Auto | Built-in AF Assist | On |
| ISO Sensitivity | Auto (100-3200) | Flash Mode | Fill Flash |
| Picture Control | Standard | Flash Control | TTL |
| Color Space | sRGB | Manual | Full |
| Active D-Lighting | On | Flash Compensation | 0.0 |
| **Other Shooting Options** | | | |
| Focus Area | Center | Focus Mode | Varies with shooting mode |
| Flexible Program | Off | Exposure Compensation | 0.0 |
| Autoexposure Lock | Off | Movie Mode | HD movie |
| Focus Lock | Off | Theme | Beauty |
| Self-timer | Off | Picture Control | Not changed by reset |

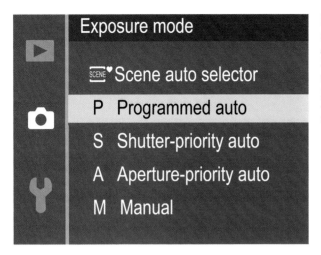

**Figure 3.6**

Select from Scene Auto Selector, Shutter-priority auto, Aperture-priority auto, and Manual exposure modes.

## Image Quality

You can choose the image quality settings used by the V1 or J1 to store its still image files from this menu entry. You have five choices, NEF (RAW)+JPEG Fine, NEF (RAW), JPEG Fine, JPEG Normal, and JPEG Basic. The RAW/JPEG choices specify the file format used to store your image on your memory card. The JPEG options tell the camera how much to compress the images.

- **JPEG, RAW, or both.** You can elect to store only JPEG versions of the images you shoot, or you can save your photos as RAW files, which consume more than twice as much space on your memory card. Or, you can store both at once as you shoot. Many photographers elect to save *both* JPEG and a RAW, so they'll have a JPEG version that might be usable as-is, as well as the original "digital negative" RAW file in case they want to do some processing of the image later. You'll end up with two different versions of the same file: one with a .jpg extension, and one with the .nef extension that signifies a Nikon RAW file.

- **JPEG compression.** To reduce the size of your image files and allow more photos to be stored on a given memory card, the V1/J1 uses JPEG compression to squeeze the non-RAW images down to a smaller size. This compacting reduces the image quality a little, so you're offered your choice of Fine (a 1:4 reduction), Normal (1:8 reduction), and Basic (1:16) compression.

# Image Size

This menu item lets you select the resolution, or number of pixels captured as you shoot with your Nikon V1 or J1. Your choices range from Large (L—3872 × 2592 pixels, 10 megapixels), Medium (M—2896 × 1944 pixels, 5.6 megapixels), and Small (S—1936 × 1296 pixels, 2.5 megapixels). Your best choice is to shoot at full resolution (Large); the other options are useful if you need a lower resolution version for e-mailing or uploading to a website, such as Facebook, and would prefer not to resize the image in an image editor.

# Continuous

This menu entry is available in Still Image mode when you haven't selected Electronic (Hi) shutter. Your choices include:

- **Single frame.** In Single frame mode, your camera takes one picture each time you press the shutter release button down all the way. You can take as many photographs in this mode as you have room for on your memory card.

- **Continuous.** This shooting mode can be set to produce bursts of up to 5 frames per second while the shutter release button is held down. You can take up to 100 pictures in a row in this mode if your memory card has sufficient storage space.

# Shutter Type (V1 only)

With the Nikon V1, this menu entry essentially duplicates the choices that appear when you press the F button while using Still Image mode. You can select Mechanical, Electronic, or Electronic (Hi) shutter types:

- **Mechanical shutter.** You'll want to use the mechanical shutter for everyday use. It offers shutter speeds from 30 seconds to 1/4,000th second. Although the electronic shutter offers higher speeds, this range is sufficient for virtually every scene you might want to photograph. It allows synchronizing the electronic flash at speeds of up to 1/250th second, and continuous shooting at up to 5fps. One drawback is the audible noise produced by the mechanical shutter.

- **Electronic shutter.** Because of its higher speeds, the electronic shutter can capture images at faster frame rates, with continuous shooting at 10, 30, or 60fps. Shutter speeds up to 1/16,000th second are available, but it can sync flash at only 1/60th second, which can produce "ghost" images, as described in Chapter 5. It is subject to an effect called blooming but has the advantage of silent operation.

■ **Electronic (Hi) shutter.** The high-speed electronic shutter also provides speeds up to 1/16,000th second, and defaults to 10fps when shooting continuously. You can also choose 30fps or 60fps. The Electronic (Hi) shutter is used for slow-motion movies at reduced resolutions, at 400fps (640 × 240 pixels) or 1200fps (320 × 120 pixels).

## Metering

As you scroll down, Metering appears on the Shooting menu list. Use this setting to choose Matrix, Center-weighted, or Spot metering:

■ **Matrix metering.** The standard metering mode; the camera attempts to intelligently classify your image and choose the best exposure based on readings from a broad span of the sensor area, matched against a database of thousands of patterns.

■ **Center-weighted metering.** The camera meters the entire scene, but gives the most emphasis to the central area of the frame, measuring about 4.5mm.

■ **Spot metering.** Exposure is calculated from a smaller 3mm spot, about 2 percent of the image area, using the center focus area, except when working with Face-priority AF mode, which meters from a focus area spot closest to the center of the selected face.

## Frame Rate

This option is available in the Shooting menu when you select Slow Motion as the Movie mode by pressing the F button when the mode dial is set to Movie. You can then choose 400fps or 1200fps as the slow-motion movie rate. Slow motion movies are silent clips recorded at the reduced aspect ratio of 8:3 at 400 or 1200 frames per second. Played back at 30fps, one second of 400fps slow-motion footage requires more than 13 seconds to play out on the screen, and one second of 1200fps footage takes 40 seconds. At 400fps, the frame size is just 640 × 240 pixels, and at 1200fps, a minuscule 320 × 120 pixels. In either case, the maximum shooting length is five seconds, which plays back in 1 minute, 6 seconds from a clip shot at 400fps to 3 minutes, 20 seconds for a clip recorded at 1200fps.

## Movie Settings

This entry appears when the mode dial is set to Movie mode, and you've selected HD Movie rather than Slow Motion from the F button options.

- **1080/60i.** This full HD, 16:9 aspect ratio format provides an interlaced video image at 60 fields per second. Use for scenes without a lot of action to get the sharpest image.

- **1080/30p.** This second full-HD format saves storage space and is best for video that has action or motion sequences.

- **720p/60 (1280 × 720 pixels).** This 16:9 format is called "standard HD" and for some types of scenes with fast movement can produce a sharper, smoother picture while using even less storage space.

## White Balance

This menu entry allows you to choose one of the white balance values applied to JPEG images (and used as the initial setting for RAW images) from among Auto, Incandescent, Fluorescent Illumination, Direct Sunlight, Flash, Cloudy, Shade, or a preset value taken from a measurement you make.

When you select the White Balance entry on the Shooting menu, you'll see an array of choices, ranging from Auto to Shade, plus Preset. For all settings other than Preset, you can highlight the white balance option you want, then press the multi selector right button (or press OK) to view the fine-tuning screen shown in Figure 3.7 (and which uses the incandescent setting as an example). The screen shows a grid with two axes, a blue/amber axis extending left/right, and a green/magenta axis extending up and down the grid. By default, the grid's cursor is positioned in the middle, and a readout to the right of the grid shows the cursor's coordinates on the A-B axis (yes, I know the display has the end points reversed) and G-M axis at 0,0.

**Figure 3.7**
Specific white balance settings can be fine-tuned by changing their bias in the amber/blue, magenta/green directions—or along both axes simultaneously.

## Using Preset Manual White Balance

If automatic white balance or one of the predefined settings available aren't suitable, you can set a custom white balance using the Preset Manual menu option.

1. **Position reference subject.** Place the neutral reference under the lighting you want to measure.

2. **Change to Preset white balance.** In the Shooting menu, select Preset Manual. A screen appears with the message *Measure a new value for preset manual white balance?* Highlight Yes and press the OK button.

3. **Capture white balance reference.** A message will appear asking you to photograph a white or gray object. After a few seconds, this message disappears, and the monitor will show the standard live view with a flashing PRE in the lower-right corner of the screen. Take the photograph.

4. **Confirm successful capture of white balance.** If the camera successfully measured white balance, a message *White Balance Captured Successfully* will appear. Otherwise, you'll see *Unable to measure present white balance. Please try again.*

5. **Use captured white balance.** You can immediately begin taking pictures using the captured white balance, until you hold down the WB button again and switch to one of the other white balance settings, such as Tungsten or Fluorescent. The next time you switch to Pre, the white balance you just captured will be used again, unless you press the right directional button to activate a new capture.

## ISO Sensitivity

This menu entry allows you to specify an exact ISO setting to use, or a range of ISO settings that the V1 or J1 will select from automatically, depending on the lighting conditions.

■ **A3200 Auto (100-3200).** The camera will choose an ISO setting from ISO 100 to ISO 3200. Under bright lighting conditions, you'll end up with a relatively low ISO setting and get your best results. Use this option when your expected lighting conditions will vary widely, and you're willing to accept some visual noise if it means you'll get a picture you might miss otherwise.

■ **A800 Auto (100-800).** With this setting, the camera is limited to ISO 100 to 800. Use this option when you'll be shooting both indoors and outdoors, or in a mixture of bright and dim light conditions, and you're willing to risk a little visual noise.

■ **A400 Auto (100-400).** This is the best setting to use when you want to avoid noise, as the camera will limit itself to the range from ISO 100 to 400.

■ **Specific values.** If you're shooting in relatively constant light levels, you can select an appropriate ISO setting and not be concerned that the camera will select a drastically different ISO setting without warning. You can select individual settings including ISO 100, 200, 400, 800, 1600, and 3200, plus Hi 1, which is the equivalent of ISO 6400.

# Picture Control

Nikon's Picture Control styles allow you to choose your own sharpness, contrast, color saturation, and hue settings and apply them to your images as they are taken. There are six predefined styles offered: Standard, Neutral, Vivid, Monochrome, Portrait, and Landscape. The V1/J1 will choose one of these to suit a particular subject if Scene Auto Selector is active. However, you can choose Picture Controls individually and *edit* the settings of any of those styles so they better suit your taste. The Nikon 1 cameras also offer *nine* user-definable Picture Control styles, which can be copied to a memory card for re-use or transfer to another camera.

Using and managing Picture Control styles is accomplished with two different menu entries. This one, Picture Control, which allows you to choose an existing style and to edit the predefined styles that Nikon provides, and Custom Picture Control, discussed in the next section, which gives you the capability of creating and editing user-defined styles.

## Choosing a Picture Control Style

To choose from one of the predefined styles (Standard, Neutral, Vivid, Portrait, Landscape, or Monochrome) or select a user-defined style (numbered C-1 to C-9, available only if you've created a custom style), follow these steps:

1. **Choose Picture Control.** This option is located in the Shooting menu. The screen shown in Figure 3.8 (left) appears. Note that Picture Controls that have been modified from their standard settings have an asterisk next to their name.

2. **Select style.** Scroll down to the Picture Control you'd like to use.

3. **Activate Picture Control.** Press OK to activate the highlighted style. (Although you can usually select a menu item by pressing the multi selector right button; in this case, that button activates editing instead.)

4. **Exit menu.** Press the MENU button or tap the shutter release to exit the menu system.

**Figure 3.8** You can choose from the predefined Picture Controls, or select a user-defined style (left); sliders can be used to make quick adjustments to your Picture Control styles (right).

## Editing a Picture Control Style

You can change the parameters of any of Nikon's predefined Picture Controls, or any of the nine user-defined styles you create.

1. **Access menu.** Choose Picture Control from the Shooting menu.

2. **Select style.** Scroll down to the Picture Control you'd like to edit.

3. **Access adjustment screen.** Press the multi selector right button to produce the adjustment screen shown in Figure 3.8.

4. **Make fast changes.** Use the Quick Adjust slider to exaggerate the attributes of any of the Picture Controls except Neutral and Monochrome.

5. **Change other attributes.** Scroll down to the Sharpening, Contrast, Brightness, Saturation, and Hue sliders with the multi selector up/down buttons; then use the left/right buttons to decrease or increase the effects. A line will appear under the original setting in the slider whenever you've made a change from the defaults. **Note:** You can't adjust contrast and brightness when Active D-Lighting (discussed later in this chapter) is active. Turn it off to make those Picture Control adjustments.

6. **Or use auto adjustments.** Instead of making changes with the slider's scale, you can move the cursor to the far left and choose A (for auto) instead when working with the Sharpening, Contrast, and Saturation sliders. The camera will adjust these parameters automatically, depending on the type of scene it detects.

7. **To Reset Values.** Press the Trash button to reset the values to their defaults and confirm by choosing Yes in the screen that appears.

8. **View adjustment grid.** Press the zoom bar up to view an adjustment grid (discussed next).

9. **Confirm changes.** Press OK when you're finished making adjustments.

Editing the Monochrome style is similar to modifying the other styles, except that the parameters differ slightly. Sharpening, Contrast, and Brightness are available, but, instead of Saturation and Hue, you can choose a filter effect (Yellow, Orange, Red, Green, or none) and a toning effect (black-and-white, plus seven levels of Sepia, Cyanotype, Red, Yellow, Green, Blue Green, Blue, Purple Blue, and Red Purple). (Keep in mind that once you've taken a JPEG photo using a Monochrome style, you can't convert the image back to full color.)

When you press the zoom bar up, a grid display appears, showing the relative contrast and saturation of each of the predefined Picture Controls. If you've created your own custom Picture Controls, they will appear on this grid, too, represented by the numbers 1-9. Because the values for autocontrast and auto-saturation may vary, the icons for any Picture Control that uses the Auto feature will be shown on the grid in green, with lines extending up and down from the icon to tip you off that the position within the coordinates may vary from the one shown.

## Custom Picture Control

The Custom Picture Control menu entry can be used to create new styles, edit existing styles, rename or delete them, and store/retrieve them from the memory card. Here are the basic functions of this menu item, which can be found on the Shooting menu directly below the Picture Control entry:

■ **Make a copy.** Choose Edit/Save, select from the list of available Picture Controls, and press OK to store that style in one of the user-defined slots C-1 to C-9.

■ **Edit the copy.** In Save Edit, highlight the copy you saved and press the right directional button, and edit the parameters as described in the last section.

■ **Save edited copy.** Press OK when finished editing, and then save the modified style in one of the user-defined slots C-1 to C-9.

■ **Remove a style.** Select Delete, choose from the list of user-defined Picture Controls (you can't remove one of the default styles), press the multi selector right button, then highlight Yes in the screen that follows, and press OK to remove that Picture Control.

## FILTERS VS. TONING

Although some of the color choices seem to overlap, you'll get very different looks when choosing between Filter Effects and Toning. Filter Effects add no color to the monochrome image. Instead, they reproduce the look of black-and-white film that has been shot through a color filter. That is, Yellow will make the sky darker and the clouds will stand out more, while Orange makes the sky even darker and sunsets more full of detail. The Red filter produces the darkest sky of all and darkens green objects, such as leaves. Human skin may appear lighter than normal. The Green filter has the opposite effect on leaves, making them appear lighter in tone. Figure 3.9 (left) shows the same scene shot with no filter, then Yellow, Green, and Red filters.

The Sepia, Blue, Green, and other toning effects, on the other hand, all add a color cast to your monochrome image. Use these when you want an old-time look or a special effect, without bothering to recolor your shots in an image editor. Several toning effects are shown in Figure 3.9 (right).

**Figure 3.9** Left side: No filter (upper left); yellow filter (upper right); green filter (lower left); and red filter (lower right). Right side: Toning effects: Sepia (upper left); Purple Blue (upper right); Red Purple (lower left); and Green (lower right).

■ **Store/retrieve style on card.** Choose Load From/Save to Card, then select Copy to Camera to locate a Picture Control on your Secure Digital card and copy it to the V1/J1; Delete from Card to select a Picture Control on your memory card and remove it; or Copy to Card to duplicate a style currently in your camera onto the Secure Digital card. This last option allows you to create and save Picture Controls in excess of the nine that can be loaded into the camera at one time. Once you've copied a style to your memory card, you can modify the version in the camera, and, in effect, create a whole new Picture Control.

## Color Space

The Nikon V1 and J1's Color Space option gives you two different color spaces (also called *color gamuts*), named Adobe RGB, and sRGB (supposedly because it is the *standard* RGB color space). These two color gamuts define a specific set of colors that can be applied to the images your Nikon 1 captures. The set of colors, or gamut, can be reproduced or captured by a given device (scanner, digital camera, monitor, printer, or some other piece of equipment).

Adobe RGB is an expanded color space useful for commercial and professional printing, and it can reproduce a wider range of colors. It can also come in useful if an image is going to be extensively retouched, especially within an advanced image editor, like Adobe Photoshop, which has sophisticated color management capabilities that can be tailored to specific color spaces. As an advanced user, you don't need to automatically "upgrade" your camera to Adobe RGB, because images tend to look less saturated on your monitor and, it is likely, significantly different from what you will get if you output the photo to your personal inkjet. (You can *profile* your monitor for the Adobe RGB color space to improve your on-screen rendition, as described below.) While both Adobe RGB and sRGB can reproduce the exact same 16.8 million absolute colors, Adobe RGB spreads those colors over a larger portion of the visible spectrum.

You'll find that sRGB is recommended for images that will be output locally on the user's own printer, as this color space matches that of the typical inkjet printer fairly closely, and is well suited for the range of colors that can be displayed on a computer screen and viewed over the Internet. If you plan to take your image file to a retailer's kiosk for printing, sRGB is your best choice, because those automated output devices are calibrated for the sRGB color space that consumers use.

# Active D-Lighting

Active D-Lighting improves the rendition of detail in highlights and shadows *while you are actually taking the photo.* If you're taking photos in a contrasty environment, Active D-Lighting can automatically improve the apparent dynamic range of your image as you shoot, without additional effort on your part. However, you'll need to disable the feature once you leave the high contrast lighting behind, and the process does take some time. You wouldn't want to use Active D-Lighting for continuous shooting of sports subjects, for example. There are many situations in which the selective application of D-Lighting using the Playback menu is a better choice. Perhaps you forgot to apply Active D-Lighting and want to use it as a post-shot effect; or, you might want to use the Playback menu so you'll have two versions, one with and one without D-Lighting.

Note that when this feature is activated, brightness and contrast Picture Control settings cannot be changed. For best results, use your V1/J1's Matrix metering mode, so the Active D-Lighting feature can work with a full range of exposure information from multiple points in the image. Active D-Lighting works its magic by subtly *underexposing* your image so that details in the highlights (which would normally be overexposed and become featureless white pixels) are not lost. At the same time, it adjusts the values of pixels located in midtone and shadow areas so they don't become too dark because of the underexposure. Highlight tones will be preserved, while shadows will eventually be allowed to go dark more readily. (See Figure 3.10.)

**Figure 3.10** No D-Lighting (left); Active D-Lighting (right).

## Long Exp. NR

Visual noise is that awful graininess caused by long exposures and high ISO settings, and which shows up as multicolored specks in images. This setting helps you manage the kind of noise caused by lengthy exposure times. Choose Off, the default setting, to disable long exposure noise reduction when you want the maximum amount of detail present in your photograph, even though higher noise levels will result. This setting also eliminates the extra time needed to take a picture caused by the noise reduction process. Select On to activate noise reduction when you don't mind that this noise-reduction process effectively doubles the time required to take a picture; you won't want to use this setting when you're rushed. Some noise can be removed later on in an image editor.

## High ISO Noise Reduction

Noise can also be caused by higher ISO sensitivity settings. High ISO noise reduction, which can be set with this menu option, may be a good option in many cases. You can choose Off when you want to preserve detail at the cost of some noise graininess. Or you can select On which is applied when ISO sensitivity has been set to ISO 800 or higher.

## Fade In/Fade Out

This movie-only setting has three options: W Fade (white) and B Fade (black), as well as Off. When you choose W or B, each scene will fade to white or black, respectively when you stop capturing. When you resume, the image will start in the faded position (either white or black) and fade into the full scene. Choose Off and no fade in/fade out will take place.

## Movie Sound Options

This entry has two adjustments to make: Microphone and Wind Noise Reduction.

■ **Microphone.** With the V1, this setting controls both the V1's built-in microphones as well as the optional Nikon ME-1 mic, or a third-party microphone you have plugged into the mic jack on the side of the camera. With the J1, only the internal microphones are affected. Choose to turn the microphone Off if you want to shoot silently (particularly if you are going to add music, voice-over, or other sound later in your movie-editing software). Or, select a sensitivity setting from Automatic, High, Medium, or Low. This is essentially a volume control for your internal microphones, or any external mic you attach.

■ **Wind Noise Reduction.** This feature can be switched On or Off, to reduce the effects of air rushing past your microphone. If you're using the V1, you can also disable the feature on the ME-1 stereo microphone by setting the switch on the back of the ME-1 mic to the Flat position.

## Interval Timer Shooting

Nikon V1 and J1's built-in time-lapse photography feature allows you to take pictures for up to 999 intervals in bursts of as many as nine shots, with a delay of up to 23 hours and 59 minutes between shots/bursts, and an initial start-up time of as long as 23 hours and 59 minutes from the time you activate the feature. That means that if you want to photograph a rosebud opening and would like to photograph the flower once every two minutes over the next 16 hours, you can do that easily. If you like, you can delay the first photo taken by a couple hours so you don't have to stand there by the camera waiting for the right moment.

The Interval Timer Shooting screen is shown in Figure 3.11. The screen shows the current settings, and has an option to Start the shooting. At the very bottom is the setting Interval/Number of Shots. Highlight that and press the right directional button to move to a second screen where you can set the parameters for your time-lapse shooting.

**Figure 3.11**
The Interval Timer Shooting main screen.

To set up interval timer shooting, just follow these steps. Before you start:

1. **Set your clock.** The camera uses its internal World Time clock to activate, so make sure the time has been set accurately in the Setup menu before you begin.

2. **Secure camera.** Mount the camera on a tripod or other secure support.

3. **Fully charge the battery.** Although the camera more or less goes to sleep between intervals, some power is drawn, and long sequences with bursts of shots can drain power even when you're not using the interval timer feature.

4. **Protect your camera.** Make sure the camera is shielded from the elements, accidents, and theft.

When you're ready to go, set up the camera for interval shooting:

1. **Select timer.** Choose Interval Timer Shooting from the Shooting menu; advance to the Interval/Number of Shots screen.

2. **Set the interval between exposures.** You can use the left/right buttons to move among hours, minutes, and seconds, and use the up/down buttons to choose an interval from one second to 24 hours. Press the right button when finished to move down to the number of intervals/shots per interval sub-screen.

---

### 👍 Tip

The interval cannot be shorter than the shutter speed; for example, you cannot set one second as the interval if the images will be taken at two seconds or longer.

---

3. **Set number of total shots.** Highlight the number of shots and select up to 999 intervals.

4. **Confirm.** Press OK to confirm your settings.

5. **Start.** When all the parameters have been entered, you'll be returned to the main Interval Timer Shooting screen. Highlight the Start option and press OK.

---

**PAUSE OR CANCEL INTERVAL SHOOTING**

Press the MENU or Playback buttons between intervals (but not when images
are still being recorded to the memory card), and the interval shooting will be
automatically canceled. A message appears on the LCD to confirm. Shooting
will also stop if you turn off the camera, rotate the mode dial to a new setting,
the memory card becomes full, or the battery dies.

---

## Vibration Reduction

Certain lenses have built-in anti-shake qualities called *vibration reduction*,
which counter the blurring effects of camera movement by shifting lens ele-
ments simultaneously to compensate. VR lenses may offer two types of vibra-
tion reduction, *normal* and *active,* and this menu item allows you to choose
between them, or switch VR off entirely. Select Normal for most subjects; use
Active, if available with your particular lens, under extra-challenging condi-
tions, such as shooting when walking or riding in a vehicle. Turn VR Off when
the camera is mounted on a tripod or other support and is not needed.
Disabling vibration saves power and keeps the camera from hunting for vibra-
tion to counter.

## Focus Mode

Use this menu entry with the Nikon J1 to choose between AF-S, AF-C, or
AF-A autofocus modes. These modes can be selected with the V1 by pressing
the down directional button.

## AF-Area Mode

The V1 and J1 have three different focus area selection modes, which can be
selected with this menu entry. I explained how to choose an AF-Area mode
fully in Chapter 2, but here's a quick recap:

- **Auto-area AF.** The V1 or J1 always selects the autofocus zone, depending
  on your subject. In AF-S, AF-A, and AF-C modes, the active focus zones
  are highlighted in the viewfinder for about one second after focus is
  achieved. Zones are not used or displayed in manual focus mode.

- **Single-point AF.** You always select the focus zone manually from 135
  different areas, using the up/down/left/right directional buttons to relo-
  cate the active zone. The zones are arrayed 15 across horizontally and 9
  vertically. Each zone overlaps the adjoining zone by about one-third, so
  each time you press the directional button, the zone will jump approxi-
  mately two-thirds the width or height.

■ **Subject tracking.** As with Single-point AF, you can select the focus zone used by the camera to autofocus. However, once you've locked in the initial zone, the camera will relocate the active zone around the screen to track the movement of your subject. While viewing your subject, the OK button activates focus area selection. Use the directional buttons to move the zone around where you want, then press OK to lock it in. The focus zone will move around the screen to track your subject, and when you press the shutter release halfway it will lock.

## Face-Priority AF

This separate Shooting menu entry is used to enable/disable the AF-area mode known as Face-priority, which can be used in conjunction with any of the other three AF-area modes. In Face-priority mode, the camera searches for up to five faces and locks in on one of them. Unfortunately, you can't select which face the camera will give priority to, except by re-framing the image. This menu entry has two options On and Off.

## Built-in AF Assist

Choose On to activate the AF-assist illuminator lamp on the front of the camera, as described in Chapter 2. The lamp will illuminate as required to help the autofocus system operate in Still Image, Smart Photo Selector, or Motion Snapshot modes when using AF-S. It also will light up as required when AF-A is activated and operating in AF-S mode, using Auto-area AF mode, or when Single-point AF is used and the center focus area is selected.

## Flash Mode (V1 only)

This menu entry appears only when you have the optional SB-N5 electronic flash mounted on the Nikon V1 and turned on. (The Nikon J1 has the same five options when the built-in flash is raised and you press the multi selector down button.) You'll find more about using all the flash options in Chapter 5. It has three options:

■ **Fill Flash.** The flash will fire all the time, even in bright lighting conditions, as supplementary illumination to brighten shadows.

■ **Red-Eye Correction.** A pre-flash fires, which will cause subjects' pupils to contract (if they are looking at the camera), reducing the effects of red eye in your photographs.

■ **Rear-curtain sync/Rear-curtain slow sync.** Causes the flash to fire just before the shutter closes, which can produce a slightly more desirable trailing "ghost" effect under high ambient lighting conditions when using flash.

■ **Slow sync.** Applies longer shutter speeds to allow ambient light to affect the exposure.

■ **Red-eye slow sync.** Like slow sync, but with red-eye correction.

## Flash Control (V1 only)

Nikon V1 users have two choices here, TTL, which activates automatic flash exposure measured through the lens, and Manual, which allows choosing full power or 1/2 to 1/32 power. I'll explain use of this control in Chapter 5.

## Flash Compensation

If you find your flash exposures are too bright or too dim, you can adjust flash exposure compensation here, selecting up to one full stop more exposure or three stops less exposure, in one-third stop increments. An indicator appears at the lower-right corner of the LCD in shooting mode when you've dialed in flash compensation. Flash compensation is "sticky" and doesn't reset when the V1 or J1 is turned off. You'll need to revisit this menu item and zero out flash compensation (change it to +/–0).

# Chapter 4

# Setup Menu Options

This chapter shows you how and why to use each of the options in the Setup menu.

## Setup Menu

The Setup menu provides options for changing the way your camera operates. You won't change these very often; except for a few settings, like Format Memory Card, these are generally of the "set it, forget it" type—until you're ready to make a specific change. (See Figure 4.1.)

- Reset Setup Options
- Format Memory Card
- Slot Empty Release Lock
- Welcome Screen
- Display Brightness
- Grid Display
- Sound Settings
- Auto Power Off
- Remote on Duration
- Assign AE/AF-L Button
- Shutter Button AE Lock

- Video Mode
- HDMI Device Control
- Flicker Reduction
- Reset File Numbering
- Time Zone and Date
- Language
- Auto Image Rotation
- Battery Info
- GPS
- Firmware Version

### Reset Setup Options

This setting returns all the Setup menu options to their factory default value, except for Video mode, Flicker Reduction, Time Zone and Date, and Language (which can only be changed manually). The default values are shown in Table 4.1.

Reset setup options

Format memory card

Slot empty release lock    LOCK

Welcome screen    OFF

Display brightness

Grid display    OFF

Sound settings

**Figure 4.1**
The first page of the Setup menu.

## Table 4.1  Setup Menu Defaults

| Option | Default | Option | Default |
|---|---|---|---|
| Slot Empty Release Lock | Locked | Remote on Duration | 5 minutes |
| | | Assign AE/AF-L Button | AE-AF lock |
| Welcome screen | Off | | |
| Display Brightness | | Shutter Button AE Lock | Off |
| LCD Brightness | 0 | HDMI Device Control | Off |
| EVF Brightness | 0 | Time Zone and Date | Not changed by reset |
| Grid Display | Off | | |
| Sound Settings | | Daylight Saving Time | Off |
| Autofocus/ Self-timer | On | Auto Image Rotation | On |
| | | GPS | |
| Electronic shutter | On | Auto Power Off | Disable |
| | | Use GPS to Set Clock | Yes |
| Auto Power Off | 30 seconds | | |

## Format Memory Card

I recommend using this menu entry to reformat your memory card after each shoot. Select this menu entry, select Yes from the screen that appears. Press OK to begin the format process.

## Slot Empty Release Lock

This entry gives you the ability to snap off "pictures" without a memory card installed—or, alternatively, to lock the camera shutter release if no card is present. Choose Enable Release to activate "play" mode or Release Locked to disable it. A red warning indicator appears on the LCD in shooting mode. The pictures you actually "take" are displayed on the LCD during playback with the legend "Demo mode" superimposed on the screen, and they are, of course, not saved.

## Welcome Screen

You can select On or Off to show/hide the "Nikon 1" welcome screen that appears when the camera is powered up. If you don't need a reminder of what camera you're using, you can turn this off.

## Display Brightness

This menu option allows you to adjust the relative brightness of the LCD display (which Nikon calls the "monitor") and (if you own a Nikon V1) the electronic viewfinder independently. When you access the menu item, a Display Brightness screen appears showing the current settings (+3 to −3) and the option of choosing which of the two you want to adjust. A screen like the one shown in Figure 4.2 appears.

Nikon V1 owners should note that the adjustment screen is shown on whichever display is active, without regard to which one you want to adjust. So, if you see the viewfinder adjustment screen on the back-panel LCD (the "monitor"), bring the camera to your eye and peer through the EVF while making the change. If adjusting the LCD display, do so on the back-panel LCD, and not through the viewfinder.

In either case, you should be able to see all 10 swatches from black to white. If the two end swatches blend together, the brightness has been set too low. If the two whitest swatches on the right end of the strip blend together, the brightness is too high. Brighter settings use more battery power, but can allow you to view an image on the back-panel LCD outdoors in bright sunlight. Use the multi selector up/down buttons or rotate the dial to make the adjustment.

**Figure 4.2**
Adjust the LCD and EVF brightness so that all the grayscale strips are visible.

When you find the brightness you want, press OK to lock it in and return to the menu. You can cancel and exit the menu system by tapping the shutter release button.

## Grid Display

Your On/Off choices in this menu item enable or disable display of the camera's grid overlay, which can be handy for lining up vertical and horizontal components of your image as you shoot. While it's not a "rule of thirds" grid layout, it may still help you in planning your compositions. (See Figure 4.3.)

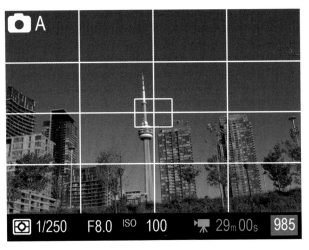

**Figure 4.3**
The grid display can help you align elements in your composition.

## Sound Settings

This entry (see Figure 4.4) allows separate enabling/disabling of the camera's sound beeper for two operational components. Highlight the sound feature you want to adjust and press the right directional button to mark/unmark the checkbox next to that feature. Press the OK button to confirm and go back to the menu, or tap the shutter release button to cancel:

- **Autofocus/Self-timer.** A beep is emitted when the camera finishes focusing, and during the self-timer countdown. If you prefer totally silent operation (say, at a religious ceremony or some other event where you want to be discrete), deactivate this sound.

- **Electronic Shutter.** The silence of the electronic shutter can be great in some circumstances, but if you're not concerned about noise, it can be helpful to hear a clicking sound as confirmation when taking a picture. You can choose either a shutter click or no sound as you prefer.

**Figure 4.4**
Specify sound settings with this entry.

## Auto Power Off

Your Nikon 1 will eventually power down the display to save battery power if you perform no operations for a specified period of time. When the displays have turned off, use any control, including a quick tap on the shutter release, to bring them back to life. You can select delays of 15 or 30 seconds, and 1, 5, or 10 minutes.

# Remote on Duration

When you use the ML-L3 infrared remote control, the camera will remain vigilant and look for a signal for a specific period of time. This uses up battery power. So, you can select active remote durations of 1, 5, 10, or 15 minutes. If the specified time expires and you haven't used the remote control, you'll need to reselect the remote control mode to activate it again.

As explained earlier, to activate the remote control, press the self-timer/remote button on the multi selector (the left button), and choose either 2s Delayed Remote or Quick Response Remote.

# Assign AE/AF-L Button

This button (the multi selector up directional button) can be programmed by you to provide two different autoexposure/autofocus locking behaviors:

- **AE/AF Lock.** With this default setting, the V1 or J1 locks both focus and exposure while the AE-L/AF-L button is pressed. In most shooting situations, when not using Auto-area autofocus (in which the camera, not you, selects what subject to focus on), this is the best compromise. You can select your focus area in the other two modes (Single-point and Subject Tracking); press the shutter release halfway to achieve both exposure and focus, and then press and hold the up button to lock them at those settings. An indicator appears at the bottom of the EVF/LCD.

  While focus and exposure are locked, you can then reframe your picture as desired, without either value changing. If you take a picture *or* remove your finger from the shutter release button, while the AE-L/AF-L button is pressed, the settings remain locked, so you can take several photographs in a row at the same focus and exposure setting.

  You'll find the AE-L/AF-L lock button handy when you're shooting subjects that aren't entirely within one of the focus zones. Frame the image and lock focus/exposure for your subject, then reframe for the final composition you want with both locked using the button.

- **AE Lock Only.** Lock only the exposure while the AE-L/AF-L button is pressed. This option is helpful when you don't want the exposure to change (say, bright or dark, but unimportant objects are wandering in and out of the frame), but want to allow focus to adjust as required.

- **AF Lock Only.** Focus is locked in while the AE-L/AF-L button is held down. In this mode, focus is locked, and you can reframe your image if necessary, but exposure will be adjusted until you take the picture.

## Shutter Button AE Lock

When switched On (the default), exposure is locked when the shutter release button is pressed halfway. If you select Off, then you'll need to press the AE/AF Lock button instead (with AE/AF Lock or AE Lock Only active, as described above) to lock exposure. When Shutter Button AE Lock is deactivated, pressing the shutter release halfway locks *only* the focus, and *only* when you're using AF-S focus mode. The Off mode is most useful when you'd like to use the shutter release to lock focus (say, to fix focus on a particular subject), while allowing the exposure to change as required.

## Video Mode (V1 only)

This setting controls the output of the Nikon V1 to a conventional video system through the video cable when you're displaying images on a monitor or connected to a VCR through the external device's yellow video input jack. You can select either NTSC, used in the United States, Canada, Mexico, many Central, South American, and Caribbean countries, much of Asia, and other countries; or PAL, which is used in the UK, much of Europe, Africa, India, China, and parts of the Middle East.

## HDMI Device Control

This option, the first on the next page of the Setup menu (see Figure 4.5) controls the Nikon V1/J1's High-Definition Multimedia Interface (HDMI) video connection, used to play back your camera's images on HDTV or HD monitors using a type C cable, which Nikon does not provide to you, but which is

**Figure 4.5**
HDMI Device Control is the first choice on the next page of the Setup menu.

readily available from third parties. Before you link up you'll want to choose the HDMI resolution to be used, from 480p (640 × 480 progressive scan); 576p (720 × 576 progressive scan); 720p (1280 × 720 progressive scan); or 1080i (1920 × 1080 interlaced scan).

You can also choose to turn Device Control on or off. When On is chosen and the camera is connected to a television that supports the HDMI-CEC protocol and both are turned on, you'll see PLAY and SLIDE SHOW messages on the television. You can then use the television's compatible remote control instead of the multi selector and OK buttons to review images and play slide shows. Choose Off, and this capability is disabled.

## Flicker Reduction

This option reduces flicker and banding, which can occur when shooting stills or movies under fluorescent and mercury vapor illumination, because the cycling of these light sources interacts with the frame rate of the camera's video system. In the United States, you'd choose the 60Hz frequency; in locations where 50Hz current is the norm, select that option instead.

## Reset File Numbering

The V1/J1's file system increments the numbers included in the file names of still photographs or movies by one with each successive capture, up to a maximum of 9999 (as with DSC_9999). Moreover, each image is deposited into a folder on your memory card which can hold up to 999 images. The folders are given a name like 100NC1V1. When 999 images are in the current folder, a new folder with a number one larger (for example 101NC1VI up to 999NC1VI) will be created.

Everything works swimmingly until the camera runs out of numbers. When you finally get to a folder numbered 999NC1V1, and that folder contains 999 images, the V1 or J1 has no place to "put" the next image, as it can't create a higher-numbered folder (it doesn't "wrap around" to 100NC1V1, in other words). The same thing happens if that 999NC1V1 folder has an image numbered DSC_9999. The shutter release locks up and you can't take any more pictures until you visit this menu entry, and in the Reset File Numbering screen select Yes. Then, you'll need to insert a new memory card or reformat the current card to continue with the new numbering scheme.

Of course, you can always reset the numbering before the system "tops out." The best reason for doing that would be to ensure that your camera doesn't lock up at an inopportune moment, by resetting a few hundred (or thousand) images before the forced rollover happens.

# Time Zone and Date

Use this menu entry to adjust the V1/J1's internal clock. Your options include:

■ **Time Zone.** A small map will pop up on the setting screen and you can choose your local time zone. I sometimes forget to change the time zone when I travel (especially when going to Europe), so my pictures are all time-stamped incorrectly. I like to use the time stamp to recall exactly when a photo was taken, so keeping this setting correct is important.

■ **Date and Time.** Use this setting to enter the exact year, month, day, hour, minute, and second, using a 24-hour clock.

■ **Date Format.** Choose from Y/M/D (year/month/day), M/D/Y (month/day/year), or D/M/Y (day/month/year) formats.

■ **Daylight Saving Time.** Use this to turn daylight saving time On or Off. Because the date on which DST goes into effect each year has been changed from time to time, if you turn this feature on you may need to monitor your camera to make sure DST has been implemented correctly.

# Language

Choose from these languages for menu display: Czech, Danish, German, English, Spanish, Greek, French, Indonesian, Italian, Dutch, Norwegian, Polish, Portuguese, Russian, Romanian, Finnish, Swedish, Turkish, Ukrainian, Arabic, Simplified Chinese, Traditional Chinese, Japanese, Korean, or Thai.

# Auto Image Rotation

Turning this setting On tells the Nikon V1 or J1 to include camera orientation information in the still image file (but not in movies or motion snapshots). The orientation can be read by many software applications, including Adobe Photoshop, Nikon ViewNX, and Capture NX, as well as the Rotate Tall setting in the Playback menu. Turn this feature Off, and none of the software applications or Playback's Rotate Tall will be able to determine the correct orientation for the image. Nikon notes that only the first image's orientation is used when shooting continuous bursts; subsequent photos will be assigned the same orientation, even if you rotate the camera during the sequence (which is something I have been known to do myself when shooting sports like basketball).

## Battery Info (V1 Only)

This screen is purely informational; there are no settings to be made. When invoked, you can see the following information:

- **Charge remaining.** The current battery level, shown as a percentage from 100 to 0 percent.

- **Battery age.** Eventually, a battery will no longer accept a charge as well as it did when it was new, and must be replaced. This indicator shows when a battery is considered new (0); has begun to degrade slightly (1,2,3); or has reached the end of its charging life and is ready for replacement (4). Batteries charged at temperatures lower than 41 degrees F may display an impaired charging life temporarily, but return to their true "health" when recharged above 68 degrees F.

## GPS (V1 Only)

This menu entry appears only when the optional GP-N100 GPS is attached and functioning. It has three options, none of which turn GPS features on or off, despite the misleading "Enable" and "Disable" nomenclature (what you're enabling and disabling is the automatic exposure meter turn-off).

- **Auto meter off.** You can choose Enable or Disable. Enabling reduces battery drain by allowing the V1 to turn off exposure meters while using the GP-N100 after the time specified for Auto Power Off in the Setup menu has elapsed. When the meters turn off, the GP-N100 becomes inactive and must reacquire at least three satellite signals before it can begin recording GPS data once more. When you choose Disable, the exposure meters remain activated continuously while using the GP-N100, so that GPS data can be recorded at any time, despite increased battery drain.

- **Position.** This is an information display, rather than a selectable option. It appears when the GP-N100 is connected and receiving satellite positioning data. It shows the latitude, longitude, altitude, and Coordinated Universal Time (UTC) values.

- **Use GPS to set camera clock.** Select Yes or No. When enabled, your V1's internal camera clock will be set using UTC values whenever the GP-N100 is attached to the camera. If you use the device frequently, this will ensure that your camera's clock is always set accurately, and won't require a manual update periodically.

## Firmware Version

You can see the current firmware release in use in the menu listing.

# Chapter 5

# Using the Flash

Your Nikon V1 can be fitted with the clip-on SB-N5 accessory flash, while the J1 has a built-in electronic flash that elevates when you push the Flash button on the upper-left back panel of the camera. Consider using electronic flash:

- **When you need extra light.** Flash provides extra illumination in dark environments where existing light isn't enough for a good exposure, or is too uneven to allow a good exposure even with the camera mounted on a tripod.

- **When you don't need a precise preview of lighting effects.** Unless you're using a studio flash with a full-time modeling lamp, electronic flash works best when you are able to visualize its effects in your mind, or don't need a precise preview.

- **When you need to stop action.** The brief duration of electronic flash serves as a very high "shutter speed" when the flash is the main or only source of illumination for the photo. Your V1's shutter speed may be set for 1/250th second, or the J1 to 1/60th second during a flash exposure, but if the flash illumination predominates, the *effective* exposure time will be the 1/1,000th to 1/50,000th second or less duration of the flash, because the flash unit reduces the amount of light released by cutting short the duration of the flash. However, if the ambient light is strong enough, it may produce a secondary, "ghost" exposure, as I'll explain later in this chapter.

- **When you need flexibility.** Electronic flash's action-freezing power allows you to work without a tripod in the studio (and elsewhere), adding flexibility and speed when choosing angles and positions. Flash units can be easily filtered, and, because the filtration is placed over the light source rather than the lens, you don't need to use high-quality filter material.

■ **When you can use—or counter—flash's relatively shallow "depth-of-light" (the inverse square law).** Electronic flash units don't have the sun's advantage of being located 93 million miles from the subject, and suffer from the effects of their proximity. The *inverse square law* dictates that as a light source's distance increases from the subject, the amount of light reaching the subject falls off proportionately to the square of the distance. In plain English, that means that a flash or lamp that's eight feet away from a subject provides only one-quarter as much illumination as a source that's four feet away (rather than half as much). (See Figure 5.1.) You can *use* this effect to separate subjects located at different distances thanks to the differing amount of illumination each receives. But when you want a larger area blanketed more evenly with illumination, you have to *counter* the effects of the inverse square law with supplemental lighting, slow shutter speeds (which allow ambient light to register along with the flash), bouncing the light off a ceiling or other surface to spread the light over a wider area, or by repositioning your subjects so all are within your flash's depth-of-light coverage.

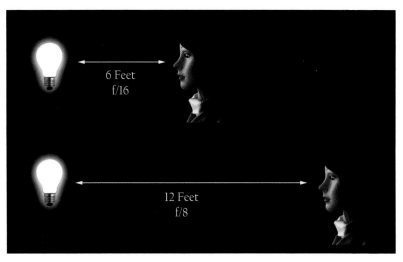

**Figure 5.1** A light source that is twice as far away provides only one-quarter as much illumination.

# Using Flash with the Nikon V1 or J1

The Nikon V1 uses the Nikon SB-N5 Speedlight, which, as I write this book is the only compatible dedicated flash unit. It's easy to work with as it uses no batteries, and is powered by the rechargeable cell in the Nikon V1. So, installation calls for simply sliding the multi accessory port cover off, and slipping the foot of the flash unit into the mount. It locks into place automatically. The components of the SB-N5 are shown in Figure 5.2.

■ **Flash lens.** The flash tube resides behind this translucent focusing lens, which directs the beam to provide coverage for focal lengths of 10mm or greater.

■ **Swivel head.** The flash head rotates a full 180 degrees left or right, so you could point it behind the camera, to the left or right sides, and any position in between. One conceivable use for the reversing feature would be to turn it around (and probably angle it up slightly) to point the flash at a white card reflector (or even a white shirt) to provide a broad, diffused light source.

■ **Tilt angle indicators.** The flash head can also be tilted upwards for bounce flash. There are stops at the 60-, 75-, and 90-degree positions. When used with the swivel head in the reversed position, you gain additional angles of 120, 150, and 180 degrees (as well as anything in between the stops), plus equivalent angles to the left and right of the camera when swiveled to one side or the other.

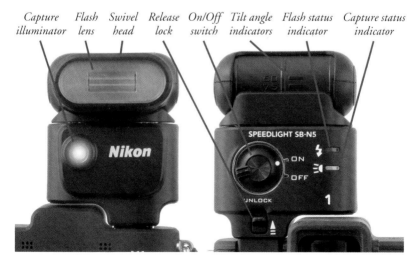

*Capture      Flash    Swivel    Release    On/Off    Tilt angle    Flash status    Capture status*
*illuminator    lens    head      lock      switch    indicators    indicator       indicator*

**Figure 5.2**  The Nikon SB-N5 flash clips onto the top of the Nikon V1 camera.

- **Capture illuminator.** This white LED illuminates in Smart Photo Selector and Motion Snapshot modes for about six seconds while the camera is buffering shots.
- **Flash status indicator.** The red top LED lights to show that the flash is charged and ready to shoot. This lamp and the capture status indicator also flash in various ways to indicate other status conditions.
- **Capture status indicator.** Glows green when the V1 is set to Smart Photo Selector or Motion Snapshot modes to indicate that the capture illuminator is ready to light up during buffering.
- **On/Off Switch.** Rotate to turn the flash on or off.
- **Release lock.** When you're ready to dismount the flash, press this button upwards to unlock the flash foot.

The J1 has a built-in flash, which, frankly, looks like something you'd build out of Lego blocks. It elevates when you press the Flash button on the upper-left corner of the J1's back panel. To retract it, just press down on the flash head. (See Figure 5.3.)

## Table 5.1  Status Light Indications

| Display | Condition |
|---|---|
| Flash Status Lamp— Steady Red | Flash is charged and ready to go. |
| Capture Status Lamp— Steady Green | Camera is in Smart Photo Selector or Motion Snapshot modes and flash is ready to provide buffering illumination. |
| Flash Status Lamp Blinks Red for 3 seconds after photo is taken | Full power flash was insufficient for exposure. Move closer or increase ISO sensitivity. |
| Either lamp blinks once per second | Flash has overheated from continuous use. Turn flash off to allow it to cool down. |
| Both lamps blink once every two seconds. | Communication error. Make sure flash is attached to the V1 firmly. |
| Flash Status Lamp blinks red eight times per second. | Internal error. Turn off camera and remove flash. Remount and try again. If error light returns have the flash serviced. |

**Figure 5.3**
The Nikon J1's flash elevates at the press of a button.

## Choosing a Flash Sync Mode

The Nikon V1 and J1 have an assortment of flash sync modes. With the V1, they are selected by choosing the Flash Mode entry in the Shooting menu. (Figure 5.4, left.) With the J1 the flash sync modes are selected by using the down directional button on the multi selector (see Figure 5.4, right). Not all modes necessarily appear in the menu at once. When using Programmed auto or Aperture-priority auto exposure modes, only Fill Flash, Red-Eye Reduction, and Rear-Curtain Sync appear. If you're using Shutter-priority auto or Manual

**Figure 5.4** Flash sync modes for the V1 are available from the Flash Mode entry in the Shooting menu (left) and for the J1 (right.)

exposure, all six are shown. When using Scene Auto Selector mode, you can choose only Fill Flash or Red-Eye Reduction; with Smart Photo Selector, there are no flash choices at all, as the camera makes all the settings. With the V1, if the SB-N5 flash is not attached, or is attached but not powered on, none of them are available; the Flash Mode, Flash Control, and Flash Compensation menu entries are all removed from the main Shooting menu.

The flash sync modes (which I've listed in logical order, so the explanation will make more sense, rather than the order in which they appear during the selection cycle) are available from the Flash Mode menu. Tables 5.2 and 5.3 list the shutter speeds available in each of the different shooting modes.

■ **Front-curtain sync (all exposure modes).** This is the default setting, and does not actually appear in the menu. It operates all the time, and applies to each of the next four sync options. The only time front-curtain sync is not used is when you select either Rear-curtain sync or Rear-curtain sync with Slow sync (described at the end of this list).

■ **Fill flash.** The flash will fire all the time, illuminating the shadows of subjects within its range. With the V1, you should set the shutter type to mechanical shutter, and must be able to use a shutter speed of 1/250th second or slower for the main exposure, as the V1 locks out faster shutter speeds when the flash is mounted and turned on. Available shutter speeds for the Nikon V1 and J1 are shown in Tables 5.2 and 5.3. With the J1, which has only an electronic shutter, you must use a shutter speed of 1/60th second or slower when the flash is elevated.

■ **Red-eye reduction (all exposure modes).** In this mode, there is a one-second lag after pressing the shutter release before the picture is actually taken, during which the camera's red-eye reduction lamp lights, causing the subject's pupils to contract (assuming they are looking at the camera), and thus reducing potential red-eye effects. Don't use with moving subjects or when you can't abide the delay.

■ **Slow sync (P and A modes only).** This setting allows the camera in Program and Aperture-priority modes to use shutter speeds as slow as 30 seconds with the flash to help balance a background illuminated with ambient light with your main subject, which will be lit by the electronic flash. You'll want to use a tripod at slower shutter speeds, of course.

■ **Red-eye reduction with slow sync (P and A modes only).** This mode combines slow sync with the V1's red-eye reduction behavior when using Program or Aperture-priority modes.

## Table 5.2  Available Shutter Speeds When Using Flash with the Nikon V1

| Exposure mode | Shutter speeds available |
|---|---|
| *Mechanical Shutter* | |
| Scene Auto Selector | 1/250-1 second |
| Shutter-Priority Auto | 1/250-30 seconds |
| Manual | 1/250-30 seconds, Bulb |
| Programmed Auto | 1/250-1/60 second |
| Aperture-Priority Auto | 1/250-1/60 second |
| *Electronic Shutter* | |
| Scene Auto Selector | 1/60-1 second |
| Shutter-Priority Auto | 1/60-30 seconds |
| Manual | 1/60-30 seconds, Bulb |
| Programmed Auto | 1/60 second |
| Aperture-Priority Auto | 1/60 second |

## Table 5.3  Available Shutter Speeds When Using Flash with the Nikon J1

| Exposure mode | Shutter speeds available |
|---|---|
| Scene Auto Selector | 1/60-1 second |
| Shutter-Priority Auto | 1/60-30 seconds |
| Manual | 1/60-30 seconds, Bulb |
| Programmed Auto | 1/60 second |
| Aperture-Priority Auto | 1/60 second |

- **Rear-curtain sync (S and M modes only).** With this setting, which can be used with Shutter-priority or Manual exposure modes, the front curtain opens completely and remains open for the duration of the exposure. Then, the flash is fired and the rear curtain closes. If the subject is moving and ambient light levels are high enough, the movement will cause a secondary "ghost" exposure that appears behind the flash exposure (trailing it). You'll find more on "ghost" exposures next.

- **Rear-curtain sync with slow sync (P and A modes only).** With this setting, which can be used with Program and Aperture-priority modes only, the front curtain opens completely and remains open for the duration of the exposure. Then, the flash is fired and the rear curtain closes. If the subject is moving and ambient light levels are high enough, the movement will cause a secondary "ghost" exposure that appears behind the flash exposure (trailing it). You'll find more on "ghost" exposures next. In Program and Aperture-priority modes, the camera will combine rear-curtain sync with slow shutter speeds to balance ambient light with flash illumination. (It's best to use a tripod to avoid blur at these slow shutter speeds.)

## Ghost Images

The difference might not seem like much, but whether you use first-curtain sync (the default setting) or rear-curtain sync (an optional setting) can make a significant difference to your photograph *if the ambient light in your scene also contributes to the image.* That can be a serious problem when using the electronic shutter of either camera, which syncs at speeds no faster than 1/60th second. Such a slow shutter speed allows sufficient ambient light that a second exposure is entirely possible.

With the V1's mechanical shutter and faster shutter speeds, particularly the 1/250th second top speed, there isn't as much time for the ambient light to register, unless it is very bright. If you're within the SB-N5's flash range, it's likely that the Speedlight will provide almost all the illumination, so the choice of first-curtain sync or second-curtain sync isn't very important.

However, at slower shutter speeds, or with very bright ambient light levels, there is a significant difference, particularly if your subject is moving, or the camera isn't steady. In any of those situations, the ambient light will register as a second image accompanying the flash exposure, and if there is movement (camera or subject), that additional image will not be in the same place as the

flash exposure. It will show as a ghost image and, if the movement is significant enough, as a blurred ghost image trailing in front of or behind your subject in the direction of the movement.

As I mentioned earlier, when you're using first-curtain sync, the flash goes off the instant the shutter opens, producing an image of the subject on the sensor. Then, the shutter remains open for an additional period, which can be from 30 seconds to 1/250th second (V1), or 1/60th second (J1). If your subject is moving, say, towards the right side of the frame, the ghost image produced by the ambient light will produce a blur on the right side of the original subject image, making it look as if your sharp (flash-produced) image is chasing the ghost. (See Figure 5.5, top.) For those of us who grew up with lightning-fast superheroes who always left a ghost trail *behind them*, that looks unnatural (see Figure 5.5, bottom).

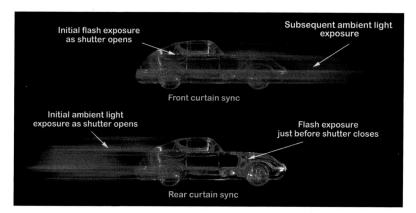

**Figure 5.5** Front-curtain sync produces an image that trails in front of the flash exposure (top), while rear-curtain sync creates a more "natural looking" trail behind the flash image (bottom).

So, Nikon provides rear (second) curtain sync to remedy the situation. With the V1, the second curtain is a physical shutter component; with the J1, that second curtain is emulated electronically. The shutter opens, as before, remains open for its designated duration, and the ghost image is captured by the sensor. If your subject moves from the left side of the frame to the right side, the ghost will move from left to right, too. *Then*, about 1.5 milliseconds before the second shutter curtain closes, the flash is triggered, producing a nice, sharp flash image *ahead* of the ghost image. Voilà! We have monsieur *le Flash* outrunning his own trailing image.

# Flash Control (V1 only)

The Flash Control entry in the V1's Shooting menu is used to switch between i-TTL (intelligent through the lens) metering, and manual exposure.

- **i-TTL.** This mode, indicated as TTL in the Flash Control menu, tells the Nikon V1 to issue a brief pre-flash just as the shutter opens (or as the electronic shutter becomes active). This pre-flash bounces off your subject and is captured by the sensor, which uses the information to determine the exposure. Because the pre-flash emits just before the main flash burst, it's not noticeable.

- **Manual.** If you select this mode, you can press the right directional button and choose a power level for the flash. Select from Full, 1/2, 1/4, 1/8, 1/16, or 1/32 power. No exposure metering is done in manual flash mode, so you'll need to estimate or adjust the exposure yourself. Manual exposure is useful when you want a specific amount of flash, perhaps because you're shooting an extreme close-up photo and i-TTL overexposes the image. Or, you might prefer slightly more or slightly less fill flash and want to use manual adjustments to tailor the power of the SB-N5 to suit. (See also Flash Compensation, described next, for another way to adjust flash exposure.) The flash compensation icon at lower right in the display blinks as a warning when the flash is activated if you've selected Manual flash exposure.

# Using Flash Exposure Compensation

You can manually add or subtract exposure to the flash exposure calculated by the V1 or J1. Just choose Flash Compensation from the Shooting menu, and select up to +1 more exposure (in one-third stop increments) or –3 stops (in one-third stop increments). The smaller range of plus exposure steps means it's more difficult to boost exposure for flash pictures that are too dark than it is to reduce exposure for overly bright images. That makes sense from a technological standpoint (it's easy to cut the flash burst short) and logical standpoint (as the flash for either camera is a bit underpowered to begin with). Flash compensation will be displayed at the bottom of the display, and is "sticky." Turning the camera or flash off does not cancel flash compensation. You must return to the menu and zero it out manually when you no longer need the adjustment.

# Chapter 6

# Movie Making with the Nikon V1/J1

Both Nikon 1 cameras are serious movie-making machines, capable of full-resolution HD movies with an aspect ratio (proportions) of 16:9, as well as reduced-resolution slow-motion video at 400 or 1200 frames per second. For conventional HD movies, just rotate the mode dial to the Movie icon, press the red movie button, located to the right of the shutter release, and the camera will begin capturing HD video with stereo sound at whatever resolution you've previously set (either 1080i/1080p or 720p). Press the movie button again to stop recording.

With the V1, if a video opportunity pops up unexpectedly while you're shooting in Still Image mode, simply move your trigger finger from the shutter release button to the movie button and press down to record non-HD movies with stereo sound at a resolution of 1072 × 720 pixels at the non-wide-screen aspect ratio (proportions) of 3:2 (the same as the still image). Press the movie button a second time to stop, or, if you see a still photo you want to take, press the shutter release button down all the way. Video recording will stop automatically as you take a still photo. There are a few set-up options to consider for more advanced shooting with either camera:

- **Select an exposure mode.** You can use any of the exposure modes when shooting HD movies. In the Shooting menu choose Exposure Mode, and opt for Scene Auto Selector, Programmed auto, Shutter-priority auto, Aperture-priority auto, or Manual.

- **Select metering mode, white balance, and ISO sensitivity.** When in Movie mode, you can select in the Shooting menu from the standard choices for metering mode (Matrix, Center-weighted, or Spot); white balance (any of the fixed options, plus your own custom presets and a color temperature in degrees Kelvin); and ISO sensitivity (any available fixed ISO setting, plus the A400, A800, and A1600 auto range choices).

- **Choose other Shooting menu settings.** Picture Controls, Custom Picture Controls, High ISO Noise Reduction, and Vibration Reduction can be specified. I'll explain these in more detail in Chapters 4 and 5, which deal with setting up all the menu options of your Nikon V1. You cannot select AF-area mode or Face-priority mode.

- **Select frame rate.** When shooting slow-motion movies (only), you can choose a frame rate of 400 or 1200fps.

- **Choose HD resolution and frame rate.** The Movie Settings entry in the Shooting menu lets you choose from 1080i/60fps, 1080p/30fps, or 720p/60fps. I'll explain when and why you should choose each of these later in the chapter. With the V1, these settings also determine the resolution of any still pictures you take while shooting movies: at 1080i, still frame captures are 3840 × 2160 pixels (7.5 megapixels); at 1080p and 720p, stills are captured at lower 2MP and 1MP resolutions, respectively.

- **Select other movie-specific settings.** In the Shooting menu you can choose movie settings such as fade in/fade out between clips, and movie sound options. I'll describe these later in this chapter.

- **Select a focus mode.** While you can't specify what focus zones are used when shooting movies, with the V1 you can press the down directional button and choose from AF-S, AF-F, or MF (Manual) focus. Make the same choices using the Focus entry in the J1's Shooting menu.

Once you've made the settings you want, you can shoot video. I've outlined the procedure earlier in this book, but here's a quick recap:

1. **Frame the movie.** You can use the display to compose your image.

2. **Focus.** Press the shutter release halfway to focus the image. The subject in the center of the frame is used to establish focus, and face detection is not used. If the camera is successful at locking in focus, the focus area will be highlighted in green; otherwise, the focus area will glow red.

3. **Lock focus/exposure.** When using an exposure mode other than Scene Auto Selector, you can lock exposure and focus by pressing the AE-L/AF-L button (the multi selector up button). You can use exposure compensation by pressing the right directional button and dialing in EV adjustments with the zoom bar. Plus or minus 3EV can be specified by pressing the bar up or down.

4. **Begin capture.** Gently press the red movie record button to begin shooting. The recording indicator will appear at the left of the frame; the time elapsed, and the time still available will be displayed.

5. **Shoot stills.** While shooting movies, you can capture up to 20 still images without interrupting the video by pressing the shutter release down all the way. Your still frame captures will be 7.5MP (in 1080i mode), 2MP (in 1080p mode), or 1MP (in 720p mode).

6. **End recording.** Press the movie record button a second time to halt recording. Movie making will also end automatically when the memory card is full, the maximum size of 4GB is reached, or the maximum time of 20 minutes is recorded.

# Choosing Resolution and Frame Rate

The Nikon 1 cameras offer two different resolutions for HD shooting using a 16:9 aspect ratio in Movie mode. The V1 has a third non-HD mode with 3:2 proportions, available only when shooting movies while in Still Image mode.

- **1080i/60, 1080p/30 (1920 × 1080 pixels).** This resolution is so-called "full HD" and conforms to the 16:9 proportions and resolution of most modern day monitors. It theoretically provides the best image for static scenes that lack a lot of motion. This resolution consumes the most space on your memory card. Note that Nikon includes the *i* and *p* after the scan/frame rate (60i, 30p) in the V1 manual, but I'm conforming to the more common practice of including it as part of the label for resolution (1080i, 1080p).

- **720p/60 (1280 × 720 pixels).** This 16:9 format is called "standard HD" and is, on first glance, lower in resolution than either of the 1080i/1080p formats. But there's a fly in the ointment, as I'll explain shortly. For some types of scenes, those with fast movement, for example, 720p can produce a sharper, smoother picture. Moreover, 720p produces smaller files that require less storage space on your memory card. Figure 6.1 compares the 16:9 proportions of the HD format with the non-HD format described next.

- **Non-HD/60 (1072 × 720 pixels).** With the V1, in Still Image mode, you can press the movie record button and shoot non-HD movies in this oddball format, which conforms to the 3:2 aspect ratio of the still photographic image. You can use this format when you don't require high-definition output, and want to conserve storage space on your memory card.

If you're shooting a relatively static image, choose 1080p/30 for the best combination of resolution and image quality. Use 1080i/60 only if you know you'll be mixing your video with existing 1080i/60 footage. For action shooting, choose 720p/60 to get the smoothest-looking image, one that's more film-like (since the *true* "filmy" look of 720p/24 isn't available with the Nikon 1 cameras).

**Figure 6.1**
Full HD and Standard HD conform to the proportions of a 16:9 aspect ratio (top); the non-HD mode produced when shooting video in Still Image mode uses a 3:2 aspect ratio (bottom).

# Shooting Slow-Motion Movies

Slow-motion movies are silent clips recorded at the reduced aspect ratio of 8:3 at the amazing speed of 400 or 1200 frames per second. Because they are played back at 30fps, one second of 400fps slow-motion footage requires more than 13 seconds to play out on the screen, and one second of 1200fps footage takes 40 seconds, producing a pronounced slo-mo effect. It's easy to get started shooting slow-motion movies. Just follow these steps:

1. **Shift to Movie mode.** Rotate the mode dial to the Movie mode position.

2. **Select Slow Motion mode.** Press the F button and use the multi selector directional buttons to choose Slow Motion. Press the OK button to confirm your choice.

3. **Select exposure mode.** Press the MENU button, choose the Shooting menu, and scroll to Exposure Mode, press OK and select Programmed auto, Shutter-priority auto, Aperture-priority auto, or Manual. Scene Auto Selector is not available.

4. **Choose settings.** When in Slow Motion movie mode, you can select from an array of other adjustments, including frame rate, white balance, ISO sensitivity, Picture Controls, and vibration reduction.

5. **Frame the movie.** You can use either the LCD or the EVF to compose your image. A wide mask showing the 8:3 slow motion filming area appears on the screen.

6. **Shoot.** Gently press the red movie record button to begin shooting. The recording indicator will appear at the left of the frame; the time elapsed, and the time still available will be displayed. The camera focuses on the subject in the center of the screen, and face detection is not available.

7. **End recording.** Press the movie record button a second time to halt recording. Movie making will also end when the maximum time of about 5 seconds is reached, when the memory card is full, the maximum size of 4GB is reached, or, if you're using a slow memory card, the buffer fills before the existing recording is saved to the card.

# Viewing Movies

You can view your movies in Playback mode. Just follow these steps:

1. **Start Playback review.** Press the Playback button. You can review your movies when the camera is set to any shooting mode. You don't need to be using Movie mode to view them. When using full-frame playback (that is, when not in thumbnail or calendar view), movies are indicated by a movie camera icon in the upper-left corner.

2. **Select a movie to review.** When the clip you want to watch is shown on the screen, press the OK button to start.

3. **Pause movie.** Stop playback at any time by pressing the multi selector down button.

4. **Single frame advance/rewind.** When the movie is paused, pressing the right directional button advances one frame; the left directional button rewinds one frame. Or, you can rotate the multi selector dial clockwise or counter-clockwise.

5. **Resume play.** Press the OK button to resume playback of the movie.

6. **Fast forward/rewind.** Press the right directional button to advance, or the left directional button to rewind. A single press increases the speed from 1X to 2X. Keep pressing to accelerate playback to 5X, 10X, or 15X.

7. **Adjust volume.** The zoom bar can be pressed up or down to increase or decrease volume.

8. **Exit to Playback mode.** Press the up directional button to return to Playback mode to select a different still image or movie to resume.

9. **Return to shooting mode.** Tap the shutter release button halfway to return to shooting mode.

# Fine-Tuning Movie Settings

Here's a summary of the various movie-related settings you can make:

- **Movie options.** When the mode dial is set to Movie, you can press the MENU button, navigate to the Shooting menu's Movie Settings entry, and choose 1080/60i, 1080/30p, or 720/60p (Nikon's terminology), as discussed previously in this chapter.

- **Fade in/Fade out.** This setting includes W Fade (white) and B Fade (black), as well as OFF. When you choose W or B, each scene will fade to white or black, respectively, when you stop capturing. When you resume, the image will start in the faded position (either white or black) and fade into the full scene.

- **Movie Sound options.** This Shooting menu entry has two adjustments to make: Microphone and Wind Noise Reduction. Choose to turn the microphone Off if you want to shoot silently (particularly if you are going to add music, voice-over, or other sound later in your movie-editing software), or a sensitivity setting from Automatic, High, Medium, or Low.

- **Vibration reduction.** Although VR also applies to still photography, it's especially important when shooting movie clips, to minimize the shakiness of a hand-held camera. Unless you want your viewers to be seasick, or

you've mounted the camera on a tripod, you'll probably want to choose Normal, or Active (for difficult situations, as when shooting from a moving vehicle), rather than Off.

■ **Flicker reduction.** When shooting under fluorescent or mercury-vapor lighting, the flickering produced can be especially visible for movie clips. Choose the frequency of your local power supply (generally 60Hz in the US) to minimize this flicker.

■ **White balance.** Like exposure, metering mode, and several other settings, white balance applies to both still and movie shooting. However, if you're shooting in an environment where the color balance can change abruptly (such as a concert), you might want to avoid the Auto setting and choose a fixed WB value instead. That will reduce the chances of the camera trying to adjust white balance in the middle of a shot or between shots.

## Editing Your Movies

In-camera editing is limited to trimming the beginning or end from a clip, and the clip must be at least two seconds long. For more advanced editing, you'll need an application capable of editing AVI movie clips. Short Movie Creator is included with your camera, and you can use that to create movies combined from still photos or Smart Photo Selector, along with Motion Snapshots, other movies, and music. Macs are furnished with the free iMovie editor, while PCs can use the free Windows Live Essentials, which includes a movie editor. To do in-camera editing/trimming, follow these steps:

1. **Select movie clip.** Press the MENU button and choose Playback. Use the directional buttons of the multi selector to navigate to Edit Movie and select it. A screen like the one shown in Figure 6.2 appears.

2. **Highlight Choose a Start Point.** Press the right directional button to produce a screen showing a scrolling list of the available movie clips on your memory card.

3. **Choose movie clip.** Use the directional buttons or rotate the multi selector to choose a clip and press OK to select it. The screen shown in Figure 6.3 appears. You must select a clip at least two seconds long.

4. **View the clip.** Press the OK button to begin playback. The down directional button will pause at any point in the clip. OK will resume playback. Pause when you reach the first frame you want to keep, and then press the down button to pause.

5. **Delete preceding frames.** Press the up directional button to delete all the frames that appear before the frame where you paused. An Edit Movie? dialog appears. Choose Yes to confirm, or No to cancel. The camera will store a copy of the movie on your memory card.

6. **Trim from the end.** To trim video from the end of a clip, watch the movie until you reach the last frame you want to keep and then press the down button to pause. Then press the up button to trim. Confirm when the Edit Movie? dialog appears.

7. **Save movie.** You'll see a Saving Movie message and an icon as the camera stores the trimmed clip to your memory card. Storage takes some time, and you don't want to interrupt it to avoid losing your saved clip. So, make sure your camera has a fully charged battery before you start to edit a clip.

**Figure 6.2**
Choose to select start point or end point.

**Figure 6.3**
Play back movie and pause at the point where you want to trim.

# Tips for Shooting Better Video

Producing good quality video is more complicated than just buying good equipment. There are a number of different things to consider when planning a video shoot, and when possible, a shooting script and storyboard can help you produce a higher quality video.

## Keep Things Stable and on the Level

Camera shake's enough of a problem with still photography, but it becomes even more of a nuisance when you're shooting video. While the Nikon V1/J1's lens image-stabilization features can help minimize this, it can't work miracles. Placing your camera on a tripod will work much better than trying to hand-hold it while shooting.

## Shooting Script

A shooting script is nothing more than a coordinated plan that covers both audio and video and provides order and structure for your video. A detailed script will cover what types of shots you're going after, what dialogue you're going to use, audio effects, transitions, and graphics.

## Storyboards

A storyboard is a series of panels providing visuals of what each scene should look like. While the storyboards produced by Hollywood are generally of very high quality, there's nothing that says drawing skills are important for this step. Stick figures work just fine if that's the best you can do. The storyboard just helps you visualize locations, placement of actors/actresses, props and furniture, and also helps everyone involved get an idea of what you're trying to show. It also helps show how you want to frame or compose a shot. You can even shoot a series of still photos and transform them into a "storyboard" if you want, as in Figure 6.4.

## Storytelling in Video

Today's audience is used to fast-paced, short-scene storytelling. Audio and video should always be advancing the story. While it's okay to let the camera linger from time to time, it should only be for a compelling reason and only briefly. It only takes a second or two for an establishing shot to impart the necessary information. For example, many of the scenes for a video document-ing a model being photographed in a Rock and Roll music setting might be close-ups and talking heads, but an establishing shot showing the studio where the video was captured helps set the scene. (See Figure 6.5, left.)

**Figure 6.4** A storyboard is a series of simple sketches or photos to help visualize a segment of video.

**Figure 6.5** Left: An establishing shot from a distance sets the stage for closer views. Right: A medium shot is used to bring the viewer into a scene without shocking them. It can be used to introduce a character and provide context via their surroundings.

Provide variety too. Change camera angles and perspectives often and never leave a static scene on the screen for a long period of time. (You can record a static scene for a reasonably long period and then edit in other shots that cut away and back to the longer scene with close-ups that show each person talking.)

When editing, keep transitions basic! I can't stress this one enough. Watch a television program or movie. The action "jumps" from one scene or person to the next. Fancy transitions that involve exotic "wipes," dissolves, or cross fades take too long for the average viewer and make your video ponderous.

## Composition

In movie shooting, several factors restrict your composition, and impose requirements you just don't always have in still photography (although other rules of good composition do apply).

Here are some of the key differences to keep in mind when composing movie frames:

■ **Horizontal compositions only.** Some subjects, such as basketball players and tall buildings, just lend themselves to vertical compositions. But movies are shown in horizontal format only. So if you're interviewing a local basketball star, you can end up with a worst-case situation. If you want to show how tall your subject is, it's often impractical to move back far enough to show him full-length. You really can't capture a vertical composition. Tricks like getting down on the floor and shooting up at your subject can exaggerate the perspective, but aren't a perfect solution.

■ **Wasted space at the sides.** Moving in to frame the basketball player means that you're still forced to leave a lot of empty space on either side.

■ **Seamless (or seamed) transitions.** Unless you're telling a picture story with a photo essay, still pictures often stand alone. But with movies, each of your compositions must relate to the shot that preceded it, and the one that follows. It can be jarring to jump from a long shot to a tight close-up unless the director—you—is very creative. Another common error is the "jump cut" in which successive shots vary only slightly in camera angle, making it appear that the main subject has "jumped" from one place to another. The rule of thumb is to vary the camera angle by at least 30 degrees between shots to make it appear to be seamless.

■ **The time dimension.** Unlike still photography, with motion pictures there's a lot more emphasis on using a series of images to build on each other to tell a story. Static shots where the camera is mounted on a tripod and everything is shot from the same distance are a recipe for dull videos.

Here's a look at the different types of commonly used compositional tools:

■ **Establishing shot.** Much like it sounds, this type of composition, as shown in Figure 6.5, left, establishes the scene and tells the viewer where the action is taking place. Let's say you're shooting a video of your offspring's move to college; the establishing shot could be a wide shot of the campus with a sign welcoming you to the school in the foreground.

■ **Medium shot.** This shot is composed from about waist to head room (some space above the subject's head). It's useful for providing variety from a series of close-ups and also makes for a useful first look at a speaker. (See Figure 6.5, right.)

- **Close-up.** The close-up, usually described as "from shirt pocket to head room," provides a good composition for someone talking directly to the camera. Although it's common to have your talking head centered in the shot, that's not a requirement. In Figure 6.6, left, the subject was offset to the right. This would allow other images, especially graphics or titles, to be superimposed in the frame in a "real" (professional) production.

- **Extreme close-up.** When I went through broadcast training back in the '70s, this shot was described as the "big talking face" shot and we were actively discouraged from employing it. Styles and tastes change over the years and now the big talking face is much more commonly used. Just remember, the camera is capable of shooting in high-definition video and you may be playing the video on a high-def TV; be careful that you use this composition on a face that can stand up to high definition. (See Figure 6.6, right.)

**Figure 6.6** Left: A close up generally shows the full face with a little head room at the top and down to the shoulders at the bottom of the frame. Right: An extreme close-up is a very tight shot that cuts off everything above the top of the head and below the chin (or even closer!). Be careful using this shot since many of us look better from a distance!

- **"Two" shot.** A two shot shows a pair of subjects in one frame. They can be side by side or one in the foreground and one in the background. (See Figure 6.7, left.) This does not have to be a head to ground composition. Subjects can be standing or seated. A "three shot" is the same principle except that three people are in the frame.

- **Over the shoulder shot.** Long a composition of interview programs, the "Over the shoulder shot" uses the rear of one person's head and shoulder to serve as a frame for the other person. This puts the viewer's perspective as that of the person facing away from the camera. (See Figure 6.7, right.)

**Figure 6.7** Left: A "two shot" features two people in the frame. This version can be framed at various distances such as medium or close up. Right: An "over-the-shoulder" shot is a popular shot for interview programs. This point of view helps make the viewers feel like they're the one asking the questions.

# Lighting for Video

Much like in still photography, how you handle light pretty much can make or break your videography. Lighting for video can be more complicated than lighting for still photography, since both subject and camera movement is often part of the process.

## Illumination

You can significantly improve the quality of your video by increasing the light falling in the scene. This is true indoors or out, by the way. While it may seem like sunlight is more than enough, it depends on how much contrast you're dealing with. If your subject is in shadow (which can help them from squinting) or wearing a ball cap, a video light, such as an LED light (starting at less than $100) can help make them look a lot better. Work lights sold at many home improvement stores can also serve as video lights since you can set the camera's white balance to correct for any color casts. You'll need to mount these lights on a tripod or other support, or, perhaps, to a bracket that fastens to the tripod socket on the bottom of the camera. A small video light, or even the few seconds of light offered by the Capture Illuminator of the optional SB-N5 for the V1, will do just fine.

## Creative Lighting

Whether we're outdoors or indoors, we're used to seeing light come from above. Videographers need to consider how they position their lights to provide even illumination while up high enough to angle shadows down low and out of sight of the camera. When considering lighting for video, there are several

factors. One is the quality of the light. It can either be hard (direct) light or soft (diffused). Hard light is good for showing detail, but can also be very harsh and unforgiving. "Softening" the light, but diffusing it somehow, can reduce the intensity of the light but make for a kinder, gentler light as well.

While mixing light sources isn't always a good idea, one approach is to combine window light with supplemental lighting. Position your subject with the window to one side and bring in either a supplemental light or a reflector to the other side for reasonably even lighting.

## Lighting Styles

At its most basic, lighting just illuminates the scene, but when used properly it can also create drama. Let's look at some types of lighting styles:

- **Three-point lighting.** This is a basic lighting setup for one person. A main light illuminates the strong side of a person's face, while a fill light lights up the other side. A third light is then positioned above and behind the subject to light the back of the head and shoulders. (See Figure 6.8, left.)

- **Flat lighting.** Use this type of lighting to provide illumination and nothing more. It calls for a variety of lights and diffusers set to raise the light level in a space enough for good video reproduction, but not to create a particular mood or emphasize a particular scene or individual. With flat lighting, you're trying to create even lighting levels throughout the video space and minimize any shadows. Generally, the lights are placed up high and angled downward (or possibly pointed straight up to bounce off of a white ceiling). (See Figure 6.8, right.)

- **"Ghoul lighting."** This is the style of lighting used for old horror movies. The idea is to position the light down low, pointed upwards. It's such an unnatural style of lighting that it makes its targets seem weird and ghoulish.

**Figure 6.8** Left: With three-point lighting. Right: Flat lighting.

■ **Outdoor lighting.** As a general rule of thumb, keep the sun behind you when you're shooting video outdoors, except when shooting faces as the viewer won't want to see a squinting subject. When shooting another human this way, put the sun behind her and use a video light to balance light levels between the foreground and background. If the sun is simply too bright, position the subject in the shade and use the video light for your main illumination. Using reflectors (white board panels or aluminum foil covered cardboard panels are cheap options) can also help balance light effectively.

## Tips for Better Audio

Since recording high-quality audio is such a challenge, it's a good idea to do everything possible to maximize recording quality. Here are some ideas for improving the quality of the audio your camera records:

■ **Get the camera and its microphone close to the subject.** The farther the microphone is from the audio source, the less effective it will be in picking up that sound. While having to position the camera and microphone closer to the subject affects your lens choices and lens perspective options, it will make the most of your audio source. Of course, if you're using a very wide-angle lens, getting too close to your subject can have unflattering results, so don't take this advice too far.

■ **Use an external microphone with the V1.** Plug a stereo or monaural mic, like the Nikon ME-1, into the microphone jack on the side of the V1, and you'll immediately enjoy better sound, because you won't be recording noises including autofocus motors or your own breathing.

■ **Turn off any sound makers you can.** Little things like fans and air handling units aren't obvious to the human ear, but will be picked up by the microphone. Turn off any machinery or devices that you can plus make sure cell phones are set to silent mode. Also, do what you can to minimize sounds such as wind, radio, television, or people talking in the background.

■ **Make sure to record some "natural" sound.** If you're shooting video at an event of some kind, make sure you get some background sound that you can add to your audio as desired in postproduction.

■ **Consider recording audio separately.** Lip-syncing is probably beyond most of the people you're going to be shooting, but there's nothing that says you can't record narration separately and add it later. It's relatively easy if you learn how to use simple software video-editing programs like iMovie (for the Macintosh) or Windows Movic Maker (for Windows PCs). Any time the speaker is off-camera, you can work with separately recorded narration rather than recording the speaker on-camera. This can produce much cleaner sound.

# Chapter 7

# Shooting Tips

Here you'll find tips on settings to use for different kinds of shooting, including recommended settings for some Shooting menu options. You can set up your camera to shoot the main type of scenes you work with, then use the charts that follow to make changes for other kinds of images. Most will set up their V1/J1 for my basic settings, and adjust from there.

## Table 7.1  Shooting Menu Recommendations #1

| Option | Camera Default | Basic Setting | Landscape | Concert/Performance |
|---|---|---|---|---|
| Shooting mode | Your choice | Still Image mode | Still Image mode | Still Image mode |
| Exposure mode | Scene Auto Selector | Program | Shutter-priority (1/500th +) | Shutter-priority (1/180th) |
| Image Quality | JPEG Normal | JPEG Fine | NEF (RAW)+JPEG FINE | JPEG Fine |
| Image Size | Large | Large | Large | Large |
| Continuous | Single frame | Single frame | Single frame | Continuous |
| Shutter type (V1 only) | Mechanical | Mechanical | Mechanical | Electronic |
| Electronic (Hi) | 10fps | 10fps | 10fps | 10fps |
| Frame rate | 400fps | 400fps | 400fps | 400fps |
| Movie settings | 1080/60i | 1080/60i | 1080/60i | 1080/60i |
| Metering | Matrix | Matrix | Matrix | Spot |
| White balance | Auto | Auto | Auto | Tungsten |
| ISO sensitivity settings | Auto (100-3200) | Auto (100-800) | Auto (100-400) | ISO 1600 |
| Picture Control | Standard | Standard | Vivid | Standard |
| Color Space | sRGB | sRGB | Adobe RGB | Adobe RGB |
| Active D-Lighting | On | On | On | Off |
| Long exposure NR | Off | Off | Off | Off |

| Option | Camera Default | Basic Setting | Landscape | Concert/Performance |
|---|---|---|---|---|
| **High ISO NR** | On | Off | Off | On |
| **Fade in/Fade out** | None | None | None | None |
| **Movie sound options** | | | | |
| Microphone | Auto sensitivity | Auto sensitivity | Auto sensitivity | Auto sensitivity |
| Wind noise reduction | On | Off | Off | Off |
| **Vibration reduction** | Active/On | Normal/On | Normal/On | Active/On |
| **AF-area mode** | Auto-area | Auto-area | Auto-area | Subject tracking |
| **Face-priority AF** | On | On | Off | On |
| **Built-in AF assist** | On | On | Off | Off |

## Table 7.2  Shooting Menu Recommendations #2

| Option | Long Exposure | Sports Indoors | Sports Outdoors | Movie |
|---|---|---|---|---|
| Shooting mode | Still Image mode | Still Image mode | Still Image mode | Movie |
| Exposure mode | Shutter-priority | Shutter-priority (1/500th-1/640th) | Shutter priority (1/10,00th +) | Aperture-priority |
| Image Quality | NEF (RAW)+JPEG FINE | JPEG Fine | JPEG Fine | -- |
| Image Size | Large | Large | Large | -- |
| Continuous | Single frame | Continuous | Single frame | -- |
| Shutter type (V1 only) | Mechanical | Mechanical | Mechanical | Electronic |
| Electronic (Hi) | 10fps | 10fps | 30fps | 10fps |
| Frame rate | 400fps | 400fps | 400fps | 400fps |
| Movie settings | 1080/60i | 1080/60i | 1080/60i | 1080/60i |
| Metering | Matrix | Matrix | Center-weighted | Matrix |
| White balance | Choose preset | Auto | Auto | Auto |
| ISO sensitivity settings | Auto (100-3200) | ISO 1600 | Auto (100-800) | Auto (100-800) |
| Picture Control | Standard | Standard | Standard | Standard |
| Color Space | sRGB | sRGB | Adobe RGB | Adobe RGB |
| Active D-Lighting | Off | Off | On | Off |
| Long exposure NR | On | Off | Off | Off |

| Option | Long Exposure | Sports Indoors | Sports Outdoors | Movie |
|---|---|---|---|---|
| **High ISO NR** | On | On | Off | Off |
| **Fade in/Fade out** | None | None | None | On |
| Movie sound options |  |  |  |  |
| Microphone | Auto sensitivity | Auto sensitivity | Auto sensitivity | Auto sensitivity |
| **Wind noise reduction** | On | Off | Off | Off |
| **Vibration reduction** | Off | Active/On | Active/On | Active/On |
| **AF-area mode** | Single-point | Subject tracking | Subject tracking | Subject tracking |
| **Face-priority AF** | Off | On | On | Off |
| **Built-in AF assist** | Off | Off | Off | Off |

## Table 7.3  Shooting Menu Recommendations #3

| Option | Portrait | Kids | Architecture | Close-Up |
|---|---|---|---|---|
| Shooting mode | Still Image mode | Still Image mode | Still Image mode | Still Image mode |
| Exposure mode | Aperture-priority (f/4-f/8) | Shutter-priority (1/500th +) | Shutter-priority (1/500th +) | Shutter-priority (1/500th +) |
| Image Quality | JPEG Fine | JPEG Fine | NEF (RAW)+JPEG FINE | NEF (RAW)+JPEG FINE |
| Image Size | Large | Large | Large | Large |
| Continuous | Continuous | Continuous | Single frame | Single frame |
| Shutter type (V1 only) | Electronic | Electronic | Mechanical | Electronic |
| Electronic (Hi) | 10fps | 30fps | 10fps | 10fps |
| Frame rate | 400fps | 400fps | 400fps | 400fps |
| Movie settings | 1080/60i | 1080/60i | 1080/60i | 1080/60i |
| Metering | Center-weighted | Center-weighted | Matrix | Spot |
| White balance | Auto | Auto | Auto | Tungsten |
| ISO sensitivity settings | Auto (100-400) | Auto (100-800) | Auto (100-400) | Auto (100-800) |
| Picture Control | Standard | Standard | Standard | Vivid |
| Color Space | sRGB | sRGB | Adobe RGB | Adobe RGB |
| Active D-Lighting | On | On | On | Off |
| Long exposure NR | Off | Off | Off | On |

| Option | Portrait | Kids | Architecture | Close-Up |
|---|---|---|---|---|
| **High ISO NR** | Off | Off | Off | Off |
| **Fade In/Fade out** | None | None | None | None |
| **Movie sound options** | | | | |
| Microphone | Auto sensitivity | Auto sensitivity | Auto sensitivity | Auto sensitivity |
| Wind noise reduction | On | Off | Off | On |
| **Vibration reduction** | Active/On | Active/On | Normal/On | Active/On |
| **AF-area mode** | Auto-area | Subject tracking | Auto-area | Subject tracking |
| **Face-priority AF** | On | On | Off | Off |
| **Built-in AF assist** | On | On | Off | On |

# Index